IMAGES
of America

LANSING

ILLINOIS

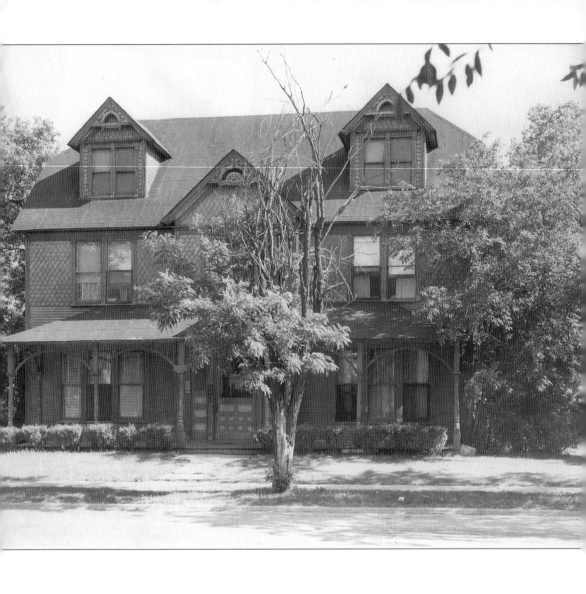

IMAGES
of America

LANSING

ILLINOIS

Carrie Elizabeth Steinweg

ARCADIA

Published by Arcadia Publishing,
an imprint of Tempus Publishing, Inc.
3047 N. Lincoln Ave., Suite 410
Chicago, IL 60657

Printed in Great Britain.

Library of Congress Catalog Card Number: 2001091442

For all general information contact Arcadia Publishing at:
Telephone 843-853-2070
Fax 843-853-0044
E-Mail sales@arcadiapublishing.com

For customer service and orders:
Toll-Free 1-888-313-2665

Visit us on the internet at http://www.arcadiapublishing.com

I dedicate this book to my husband, Paul; my little boys, Bradley and Chandler; and my parents, Darrell and Kathie Clark, who provided me with the time and support needed to complete this project. I also dedicate this book to my friend, Mary Ann Rush, who is always encouraging and proud of my creative projects. This book is likewise dedicated to the memory of Delma Walter, my beloved neighbor, who sparked my interest in the history of Lansing through her stories and memories of the neighborhood in the days long ago.

CONTENTS

ACKNOWLEDGEMENTS

I owe thanks to several people who made this publication possible. I thank all those who have worked with the Lansing Historical Society over the years to preserve these precious pieces of history. Without the assistance of Don Olson, Paul Schultz, and Loretta Johnson, the completion of this project would not have been possible. Maxine Olson, Jackie Protsman, Jeanette Cobb, Tom Coster, and Cornelius Eenigenburg—through sharing photos and memories—were also instrumental in compiling materials for this book.

INTRODUCTION

Twelve thousand years ago, the area we now know as Lansing, Illinois, lay 60 feet beneath the surface of Lake Michigan. As the years passed and the waters receded, the area was inhabited by Woodland and Hopewell Indians. In the mid-1800s, Dutch and German immigrants began to settle in the area, which then consisted of prairies, marshes, and heavy timber.

Lansing's main street, Ridge Road, was so named for the sand ridge that remained from the high prehistoric beach which once existed there. The first family to settle in the area was Mr. and Mrs. August Hildebrandt and their son in 1843. However, the town was named for Henry Lansing, who became the first postmaster in 1865. Henry, with brothers John and George, came to the area from New York in 1846. At the time, many communities were named for the man who served as postmaster. Henry's brother, John, laid out the town plat in 1865.

The first documented business, the Union Hotel, was built in 1855. It was owned by the elder Henry Krumm and was situated at the southwest corner of Ridge Road and Church Street (now Wentworth Avenue). Just west of the Union Hotel, Henry Lansing's General Store was later built, becoming the first post office. A saloon, shoemaker shop, and two blacksmith shops followed on Ridge Road.

The boundaries of the village expanded in 1893, when the village incorporated to include two nearby communities, Oak Glen and Bernice. The main area of Oak Glen was near Indiana Avenue and Yates Avenue (now Torrence Avenue). Bernice was located in today's northern portion of Lansing.

In 1861, the Pennsylvania Railroad began servicing the area with three stations. The Lansing station was located just south of Ridge Road. Christian Schultz took this opportunity to start a hay pressing business, shipping up to 5,000 tons of hay per year to as far as St. Louis, Louisville, and Cincinnati. The original Lansing depot still stands, though it has been vacant for years. Another station was Bernice, which was situated near Bernice Avenue. The other station was Globe, located near the Globe Rendering Factory.

The early homes and businesses of Bernice were built near the Bernice Railroad Station. The town originally consisted of three taverns and a boarding house. Homes were built in the area to house the families of workers at the area's brickyards.

What became the Oak Glen area was actually established prior to the existence of the Grand Trunk Railroad. In 1851, a minister named Kris Cummings came to the area with hopes of starting a college. With only four interested individuals, the college never came to be, but the area that is now Indiana Avenue and Torrence Avenue became known as Cummings Corner.

For a short time, the area was also known as Seester before being named Oak Glen. In the 1870s, several other families settled in the area to farm. Popular crops were corn, oats, and rye, and later cabbage, onions, and sugar beets. The area had grown by 1880, to include a post office, a general store, a jail, a shoe store, two blacksmith shops, two butcher shops, and four saloons. The area's first public school was built in Oak Glen at Indiana Avenue and School Street.

At least six Lansing men were drafted to serve in the Civil War in 1861 and 1862. Several of them returned permanently to the area—only one of them having been wounded.

In the late 1800s, the emergence of several brickyards caused growth in the Bernice and Lansing areas, with men coming from as far as Canada to work in the brickyards. In 1887, the Harlan Brickyard opened, located north of 178th Street between what is now Torrence Avenue and Chicago Avenue. It is believed that two clayholes were actually dug prior to Harlan's existence. Those two clayholes are now Flannigan Lake and a private lake on the Knights of Columbus grounds, which was called Purington Brick Company. In 1892, the Lahban Brickyard was established at the present site of the Lansing Country Club. The Illinois Brick Company later opened two more brickyards and purchased the Harlan and Lahban Brickyards. The Lahban Brickyard and Harlan Brickyard (later known as Brickyard 30) had both ceased operations by 1930. Brickyard 40 was the last operating brickyard, and it is now the Sexton Landfill.

At the time Lansing incorporated in 1893, the population was 256. By 1930, the population neared 3,400, and in 1940, it had grown to over 4,400. The population boomed after World War II, and by 1960, just over 10,000 people resided in the village. Today nearly 30,000 residents make up the Village of Lansing.

Despite the growth that Lansing has seen over the years, it seems to have maintained that small town feel. Many of the men and women who helped to establish Lansing are still touching our town through their descendants, who have kept the values of family commitment, community service, and consideration for their neighbors. Some longtime residents recall happy memories of ice cream parlors, roller-skating, and playing baseball. Others recall family stories of hay rides, community dances at Busak's Tavern, a sauerkraut factory, dog races that were frequented by Al Capone, picnics at Bock's Grove, or silent movies. Lansingites of any age can recall parades.

Mention of Lansing in the old days evokes a myriad of memories. Some remember lining up as teenagers hoping to land a job at the new McDonald's restaurant on Torrence Avenue. Some recall watching as the Lansing Reformed Church burned on a bitter winter night. Others talk of warming up in a bakery (now hair salon) while waiting for a bus to transport them to Thornton High School in Harvey. Many remember vividly the day that famous golfer, Tony Lema, and his wife died in a plane crash in Lansing. And some describe the scent of onions growing in nearby fields as if they are right in front of their noses.

The dirt roads have all disappeared. The farm fields have been built upon. Brick has not been produced in Lansing for over seven decades. However, this precious collection of photographs captures the unity, kinship, and harmony that brought together three communities of hardworking immigrants. I'm happy to have the opportunity to take part in preserving these images and memories of Lansing's proud past for generations to come.

One
LANSING FAMILIES

"Many members of Lansing's early families married each other—the Erferts, Winterhoffs, Shultzes, Langes. Those families are so intertwined it's unbelievable."

—Paul Schultz

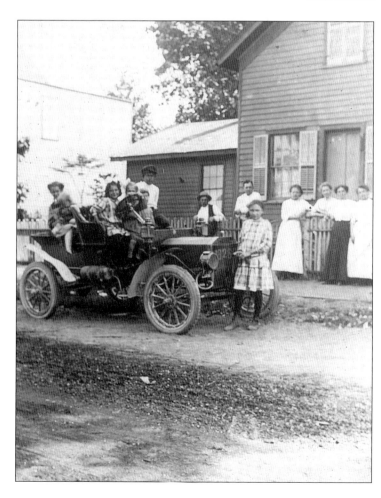

Mr. and Mrs. August Hildebrandt and son Henry were the first settlers in the area now known as Lansing. They arrived in 1843, and farmed on what is now Torrence Avenue, south of the Grand Truck Railroad. Henry Hildebrandt was one of five Lansing men to serve in the Union Army during the Civil War. After returning from the war, he donated land for the Trinity Lutheran Church. Henry Hildebrandt also served on the board of the Indiana Avenue School. Pictured is Henry Hildebrandt and his wife. (Photograph courtesy of the Lansing Historical Society.)

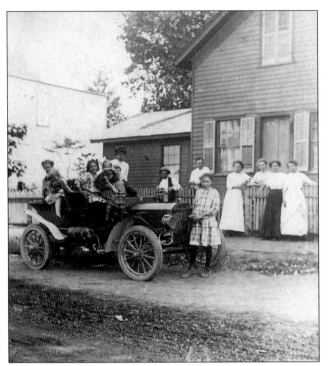

The Frey family gathers for a photo at the home of Emil Frey Sr. at Ridge Road and Sherman Street. (Photograph courtesy of the Lansing Historical Society.)

This school photo features Anna Bock (top row, third from left), one of the children of the influential Bock family. Henry Bock and his family settled in Cummings Corner, later known as Oak Glen. He bought Sertsy's blacksmith shop, and with William Bissert built the first brick homes in Lansing. One of his sons, Gustav, owned the Gus Bock Hardware store, which is still in business in Lansing and is the namesake of Bock Park. (Photograph courtesy of the Lansing Historical Society.)

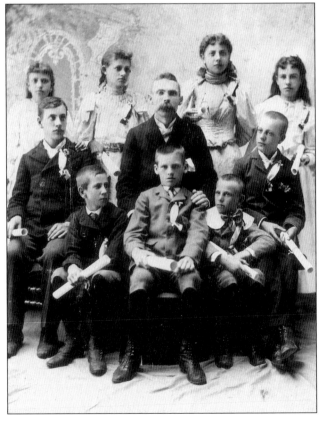

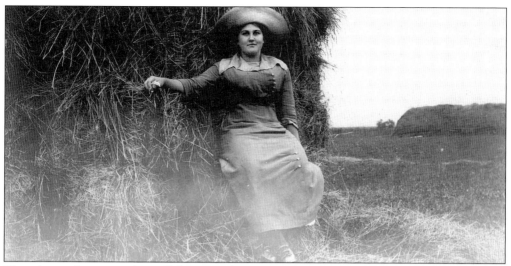

This photo of a young Anna Erfert was taken at an area that later became the Ford Airport. (Photograph courtesy of the Lansing Historical Society.)

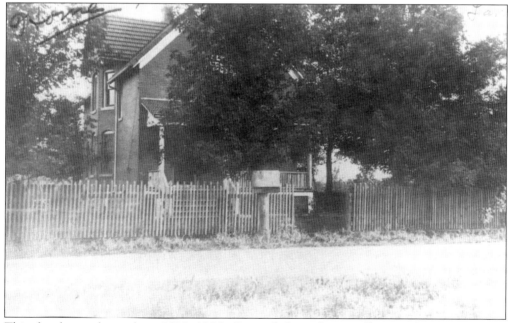

This farmhouse located at 3337 186th Street belonged to William and Anna Schultz. (Photograph courtesy of the Lansing Historical Society.)

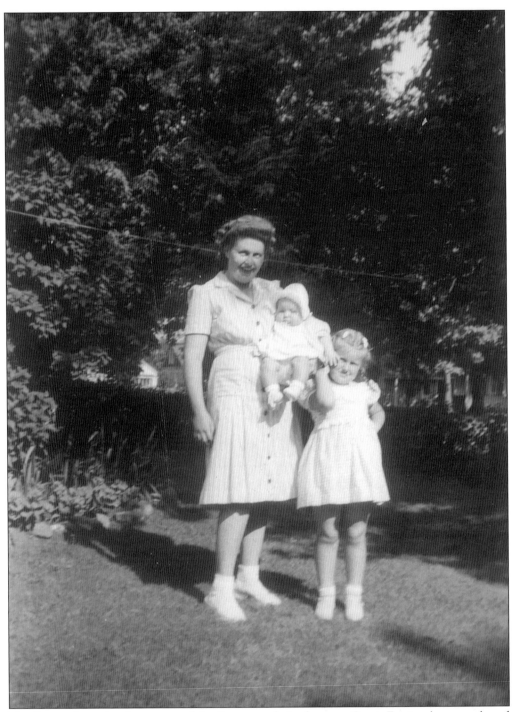

The Eenigenburg family was one of the first to settle in the area. Gerrit Eenigenburg purchased 160 acres of land where he farmed and raised his three sons and three daughters. Three of their other children were lost at sea after they left Holland in 1849 for the United States. Pictured are descendants Marsha (girl standing) and Phyllis (baby) Eenigenburg with their mother. (Photograph courtesy of the Lansing Historical Society.)

Written on the back of this photograph is "Venie & Loretta Confirmation." One or both of the girls were members of the Frey family. (Photograph courtesy of the Lansing Historical Society.)

Like many late nineteenth century photos, this one captures children Bill and Clara Schmidt in a serious pose. (Photograph courtesy of the Lansing Historical Society.)

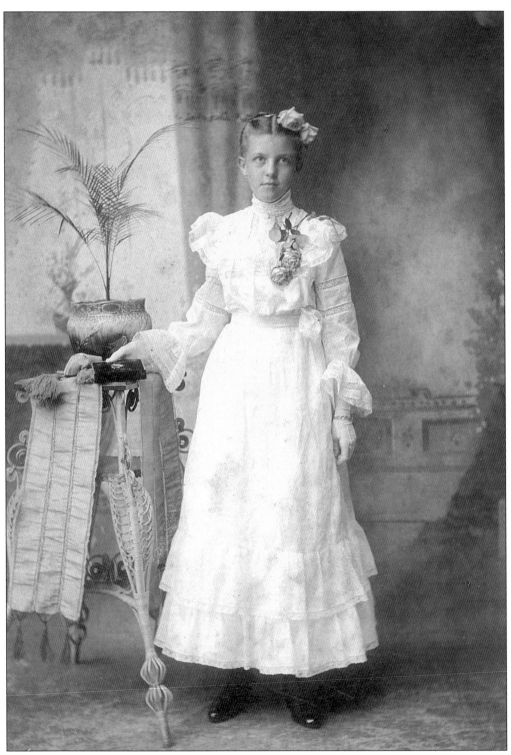

Ida Mueller dons her confirmation dress in this photograph taken around 1902. (Photograph courtesy of the Lansing Historical Society.)

Martha Mueller, presumably the sibling of Ida, was confirmed two years later. (Photograph courtesy of the Lansing Historical Society.)

This photograph of Mueller children Charlie and August was taken around 1886. The Mueller homestead was on Ridge Road at the state line, near what is now the Strack and Van Til grocery store. (Photograph courtesy of the Lansing Historical Society.)

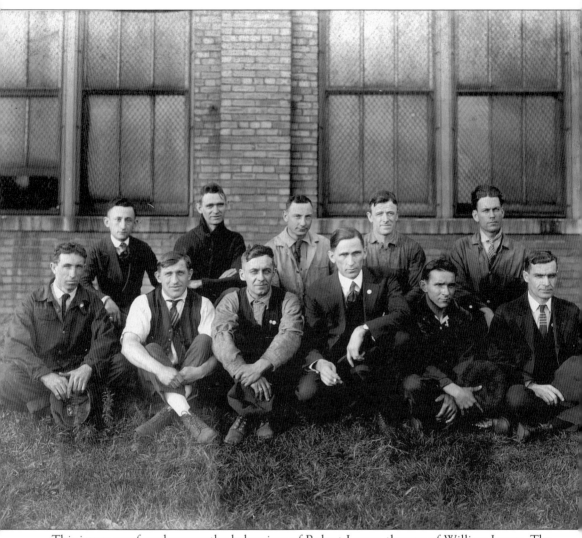

This image was found among the belongings of Robert Lange, the son of William Lange. The men photographed were likely workers of one of the Lansing brickyards around 1900. (Photograph courtesy of the Lansing Historical Society.)

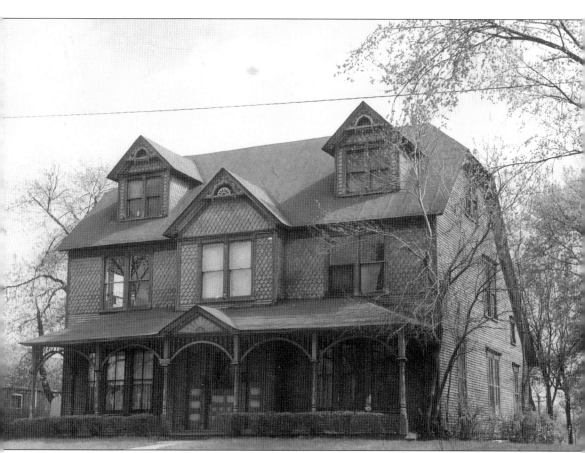

One of the first documented homes in Lansing was the residence of the Hufenheiser family, which was merely a small log cabin built in 1848 on Ridge Road. Pictured here is the home of Alfred Van Steenberg—quite a contrast to the simple Hufenheiser home. This ornate three-story home was built around 1880. Mr. Van Steenberg's father, Cornelius, was one of the early settlers in the area, and he made his living as a farmer, having purchased land from the government for $1.25 an acre. Alfred served as the village mayor from 1897 until 1931, except for the years of 1919–21, when Arnold Vierk was named mayor. Cornelius was one of the founders of the Lansing schools, and he owned a tavern in Riverdale near the Calumet River Bridge. (Photograph courtesy of the Lansing Historical Society.)

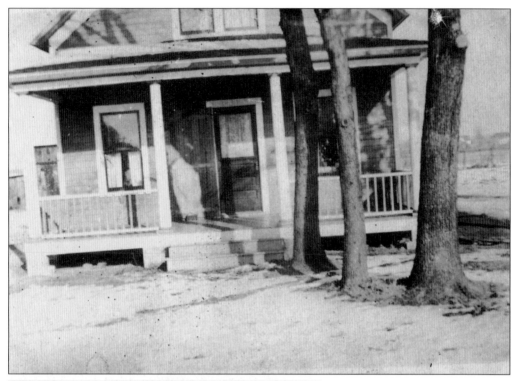

This home, built in 1916, stood at 2306 Thornton Road (now Thornton-Lansing Road). The Rinkenberger family owned the home. (Photograph courtesy of the Lansing Historical Society.)

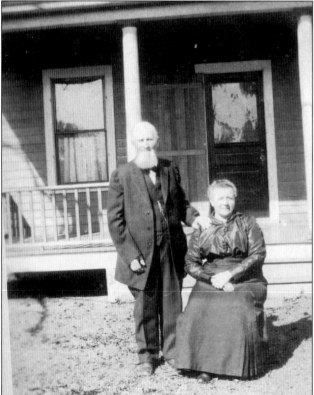

Fred and Mary Rinkenberger pose in front of their home on Thornton Road. (Photograph courtesy of the Lansing Historical Society.)

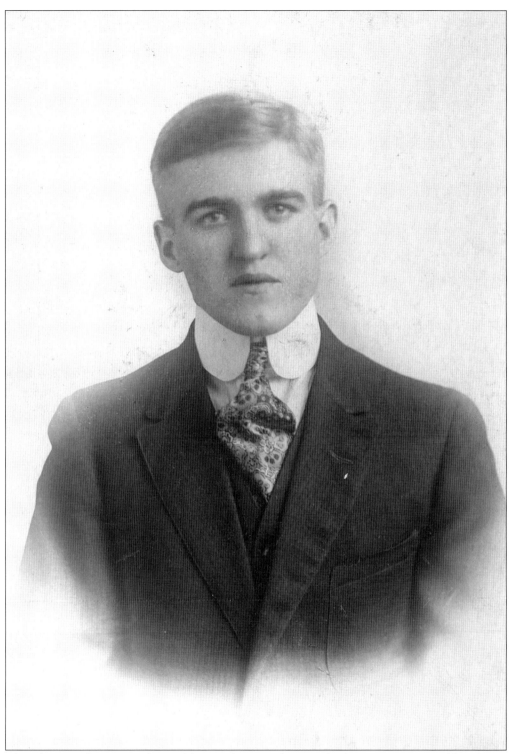

This photographic postcard, possibly a graduation photograph, features a young and handsome Herman Rahn Jr. (Photograph courtesy of the Lansing Historical Society.)

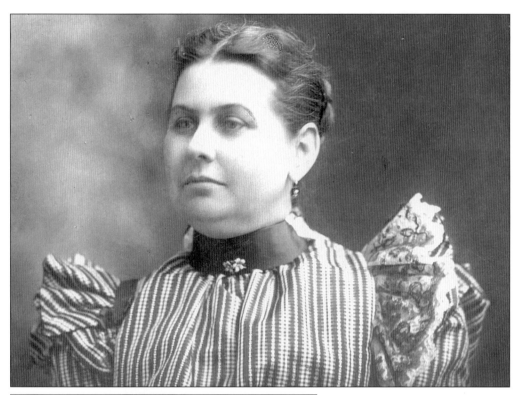

This picture of Kate Henneaux Josselyn Martin was taken around 1910. (Photograph courtesy of the Lansing Historical Society.)

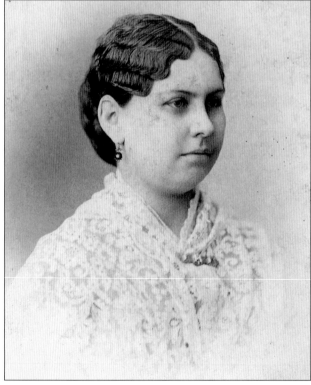

This is an earlier image of Kate Henneaux Josselyn Martin, taken shortly after she was married in 1879. (Photograph courtesy of the Lansing Historical Society.)

This is the father of Kate Martin, Henry Josselyn Martin, who was born in Jamaica and educated in England and France. He came to the United States in 1840. (Photograph courtesy of the Lansing Historical Society.)

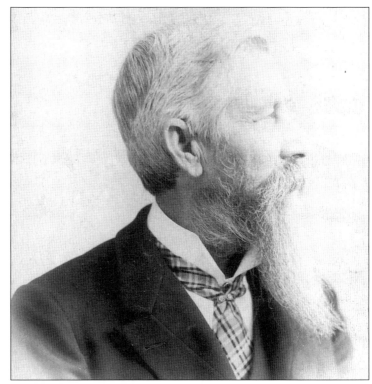

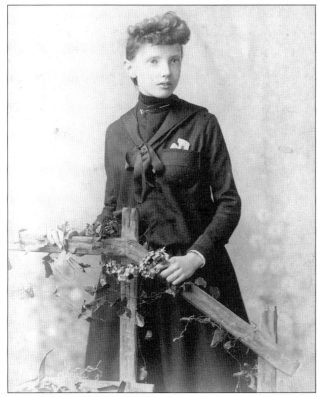

Perhaps a sibling of Kate Martin, this photo from the Martin family simply reads "Sadie—15 years." (Photograph courtesy of the Lansing Historical Society.)

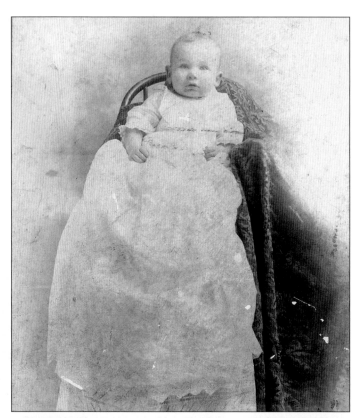

This 1896 image shows little Arthur Frey in his Christening gown. (Photograph courtesy of the Lansing Historical Society.)

Carl Rahn (right) stands at the counter of his general store. (Photograph courtesy of the Lansing Historical Society.)

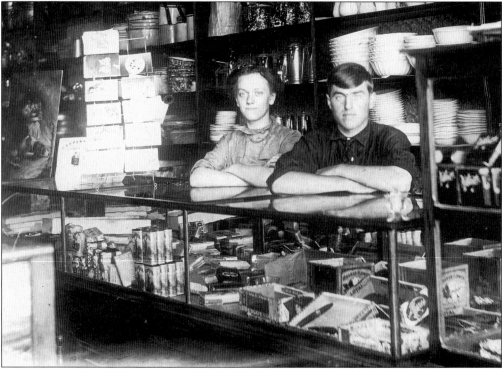

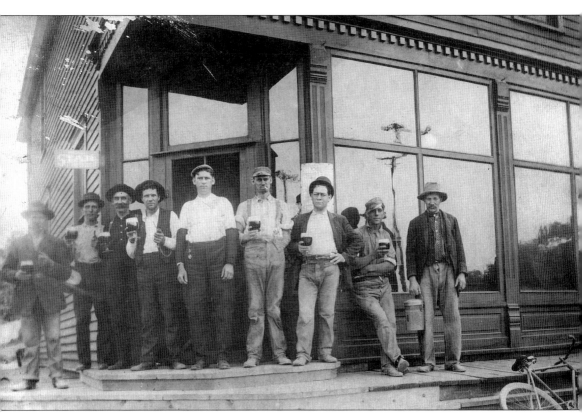

Some Lansing men enjoy a drink at a neighborhood tavern. (Photograph courtesy of the Lansing Historical Society.)

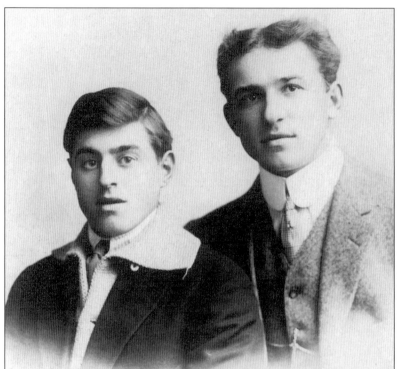

Carl Rahn and Paul Hildebrandt are pictured here. (Photograph courtesy of the Lansing Historical Society.)

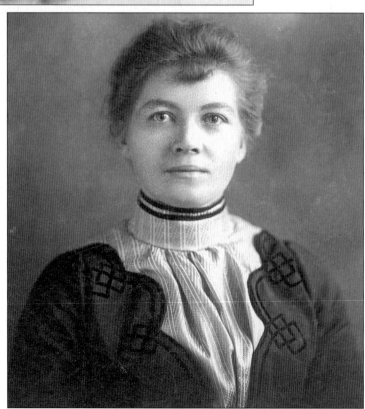

Shown here is Mary Schultz, aunt of Carl Rahn. (Photograph courtesy of the Lansing Historical Society.)

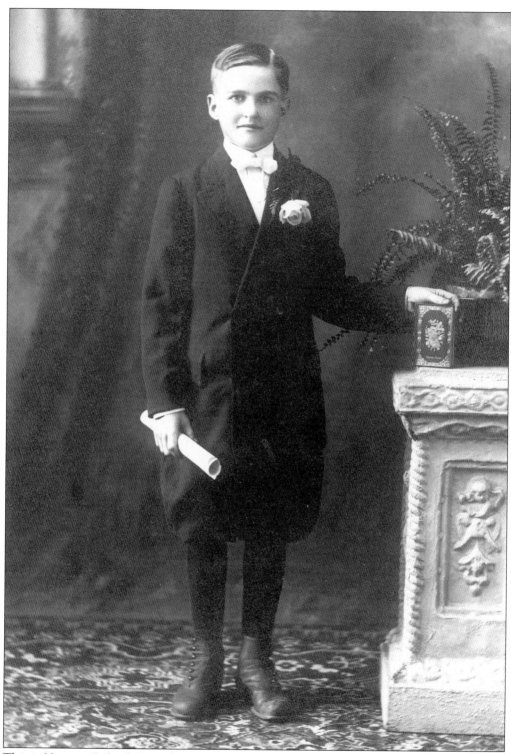

This is Herman Rahn Jr.'s confirmation photograph, taken in 1910. (Photograph courtesy of the Lansing Historical Society.)

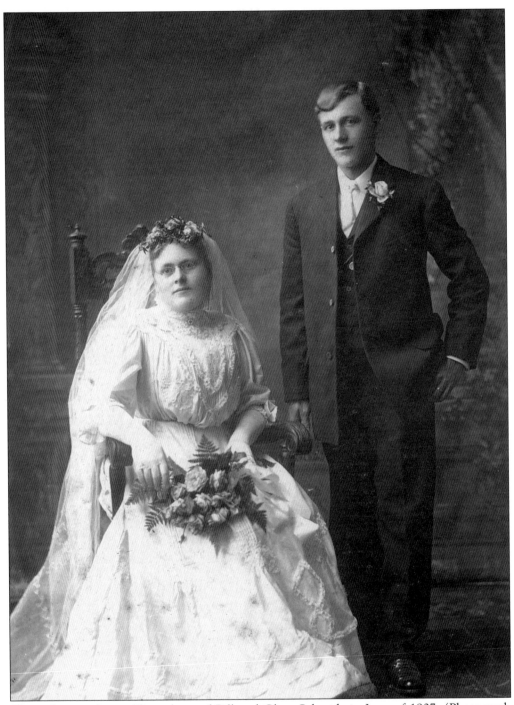

Shown here is the wedding photo of Bill and Clara Schmidt in June of 1907. (Photograph courtesy of the Lansing Historical Society.)

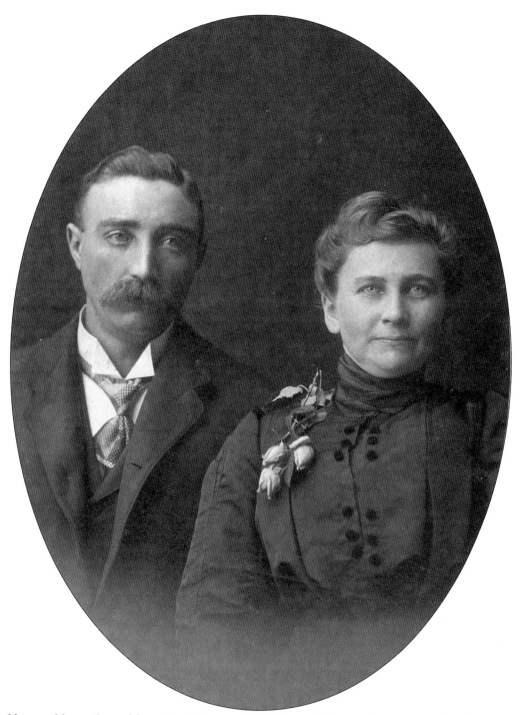

Herman Voeste Jr. and his wife Belle are pictured here. (Photograph courtesy of the Lansing Historical Society.)

Shown here is former Fire Chief and Mayor of Lansing, Evert Schultz. (Photograph courtesy of the Lansing Historical Society.)

Two
SCHOOLS

The Lansing Public School, which later became known as the Indiana Avenue School, opened in 1894, serving the communities of Lansing, Oak Glen, and Bernice. It replaced a small, white frame schoolhouse built in 1860. The school was constructed to house 50 students and two teachers. School board minutes from 1897 indicate that Principal William Welton earned a salary of $90 per month, teacher Miss Groins earned $60 per month, and a new teacher for the primary grades, Miss Kendall, earned $50 per month. The Indiana Avenue school saw some expansion in 1923, when a gymnasium and two new classrooms were added. The steeple was also later removed from the top of the school. In 1970, the Indiana Avenue School was demolished to make way for a new library. Ten schools now serve the Village of Lansing.

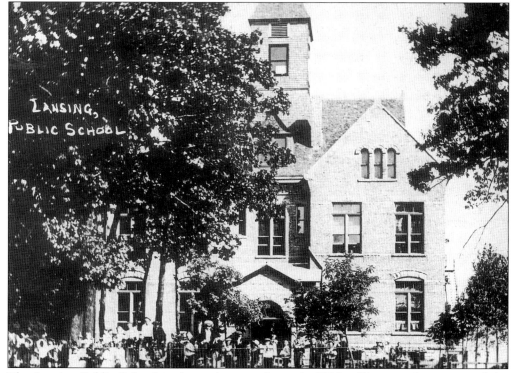

The Lansing Public School is shown here in the early 1900s. (Photograph courtesy of the Lansing Historical Society.)

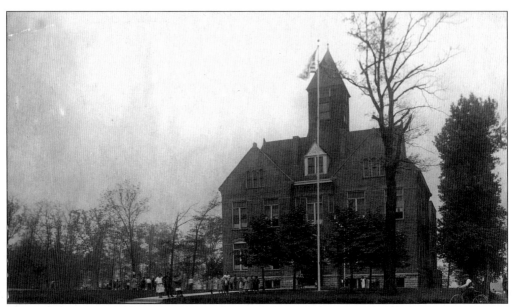

This is the Lansing Public School around 1925. (Photograph courtesy of the Lansing Historical Society.)

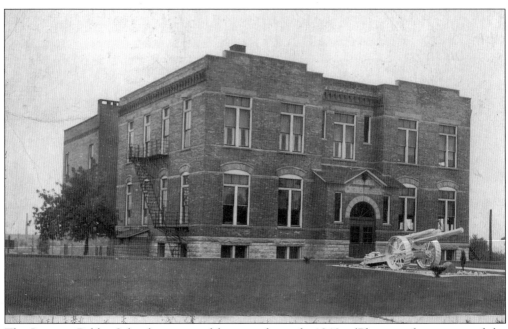

The Lansing Public School is pictured here in the early 1940s. (Photograph courtesy of the Lansing Historical Society.)

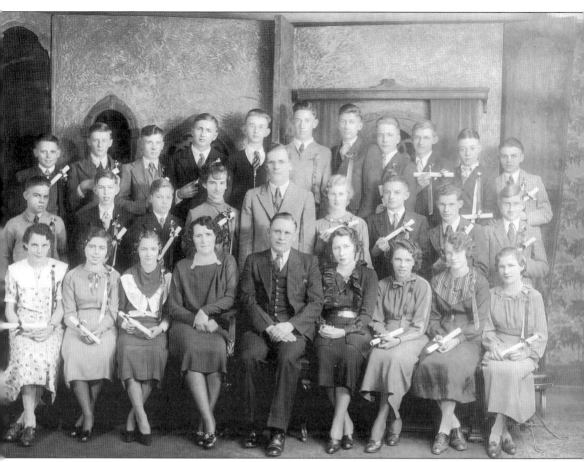

As the population of the area grew, so did the class size of the Indiana Avenue School. Only two boys graduated from the school in 1894, but by the time this photograph of the class of 1935 was taken, the number of students had increased greatly. (Photograph courtesy of the Lansing Historical Society.)

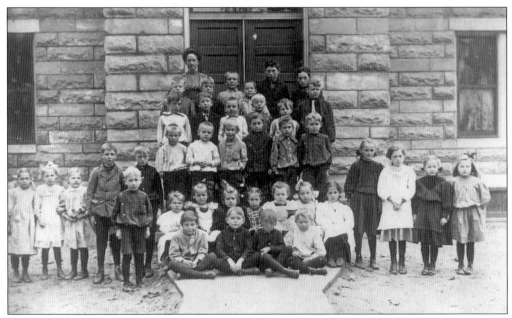

Young students gather for a 1909 photograph at the Munster Christian School in nearby Munster, Indiana. The school was later moved to Lansing and became Lansing Christian School. (Photograph courtesy of the Lansing Historical Society.)

The Munster Christian School is shown as it appeared in 1909. (Photograph courtesy of the Lansing Historical Society.)

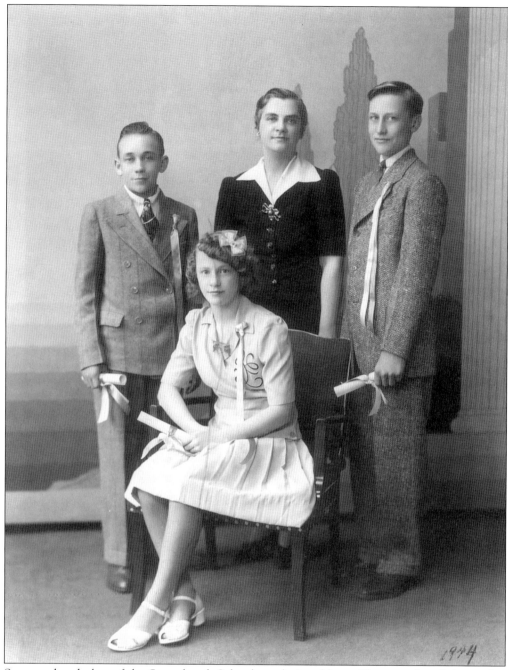

1944

Some early scholars of the Sunnybrook School are depicted here. They are, from left to right: (standing) Ralph Douma, Lucille Rinkenberger, teacher, and Robert Brumm; (seated) Carla Baer. (Photograph courtesy of the Lansing Historical Society.)

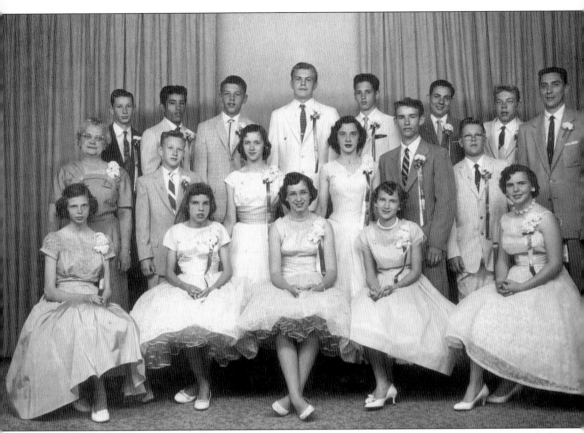

Pictured here are 1960 graduates of the Sunnybrook School. (Photograph courtesy of the Lansing Historical Society.)

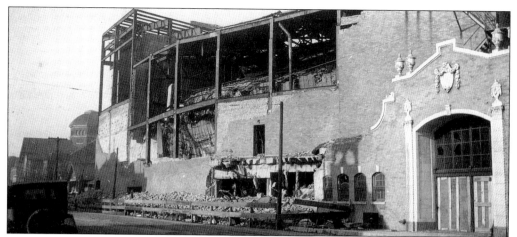

Prior to the opening of Thornton Fractional South High School in 1958, many Lansing high school students attended Thornton Fractional High School in Calumet City. Although students could attend Thornton Township High School in Harvey for free, many chose to pay tuition and attend Thornton Fractional High School, since it was much closer. Pictured is the original building following the fire in December 1933. (Photograph by Walter Schultz, courtesy of the Lansing Historical Society.)

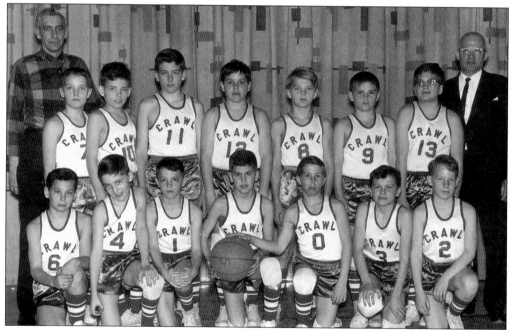

The eager basketball team of the Lester Crawl School poses for a group photo in 1967. Members of the team included the following students (not in order and not all included in the photo): Gary Booker, Tony Gabriella, Tom Mitchell, Len Winkler, Stephen Kloduryk, Donnie Heliene, Robert Seavers, John Banton, John Martinson, Stan Rossman, Rich Van Goys, Charles Allen, Scott Hamann, Jeffrey Symma, Donald Ambuehl, Mike Armstrong, Charles Cotterell, Eric Guth, Paul King, David Vanderly, Roger Kenler, George Sullivan, Clyde Bedell, Lonnie Werner, Roger Tegtmeyer, and Larry Nelson. (Photograph by Jerrell's Studio, courtesy of the Lansing Historical Society.)

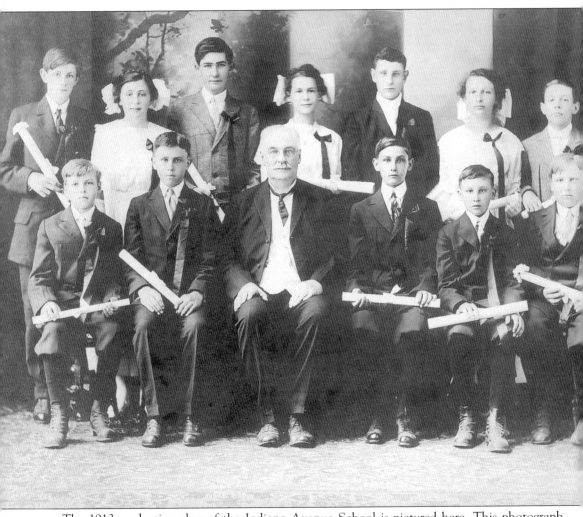

The 1913 graduating class of the Indiana Avenue School is pictured here. This photograph includes (in no particular order) William Erfert, Anna Van Heest, Jacob Hook, Delia Frey, Walter Winterhoff, Rieka Dommer, Raymond Schultz, and Cornelius Van Wheelden. Teachers for the class were Edwin Rose, Mr. D.W. Gamble, Albert Vanderlinden, Simon Fieldhouse, and Egbert Van Kley. (Photograph courtesy of the Lansing Historical Society.)

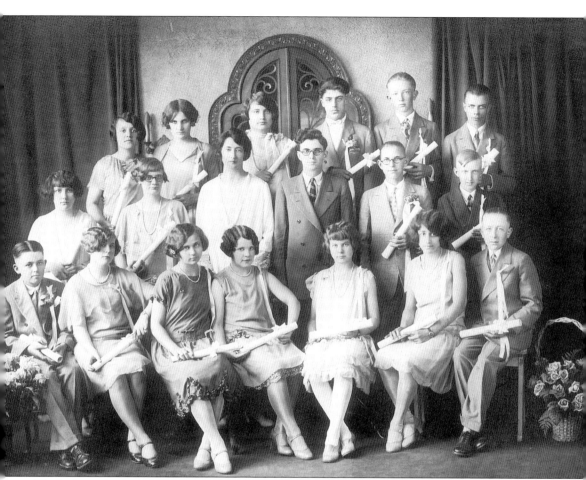

The Indiana Avenue School eighth grade class of 1926 is shown here. They are as follows, from left to right: (row 1) Percy Spork, June Reed Lange, Helen Lorenz, Merle Ward, Helen Burgerson, Dora Milazzo, Marvin Lorenz; (row 2) Winnie Murray, Margaret Van Linden, Mrs. Wicker, Mr. Sheehan, Walter Brumm, Wilbur Wolffe; (row 3) Catherine Osterella, Dorothy Eckstein, Alba Frigo, and Alfred Skaff. (Photograph courtesy of the Lansing Historical Society.)

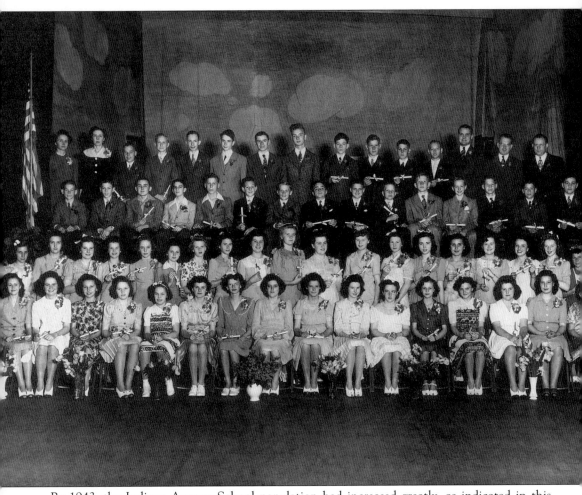

By 1943, the Indiana Avenue School population had increased greatly, as indicated in this eighth grade graduation photo. (Photograph courtesy of the Lansing Historical Society.)

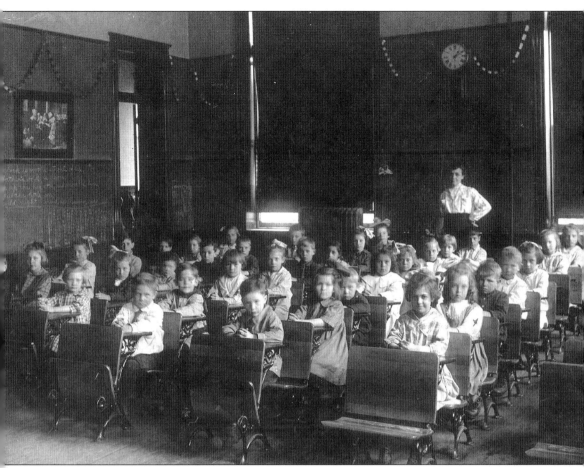

This is a 1917 classroom photo of Miss Warfal's first grade class at the Indiana Avenue School. (Photograph courtesy of the Lansing Historical Society.)

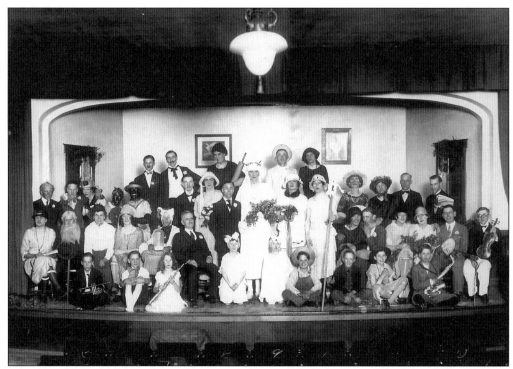

Do some of the actresses in this photo look a little masculine? That's because the photo depicts the cast of a 1928 play at the Indiana Avenue School entitled "An All Male Wedding." Teacher Mr. Elder played the groom. (Photograph courtesy of the Lansing Historical Society.)

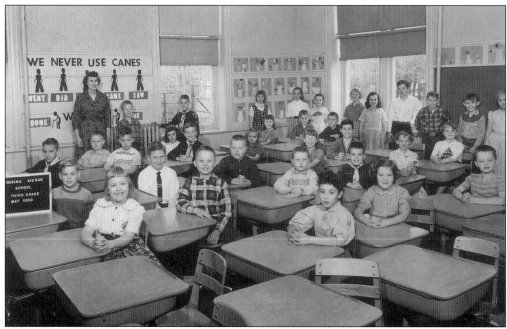

The 1960 third grade class of the Indiana Avenue School is pictured here. (Photograph courtesy of the Lansing Historical Society.)

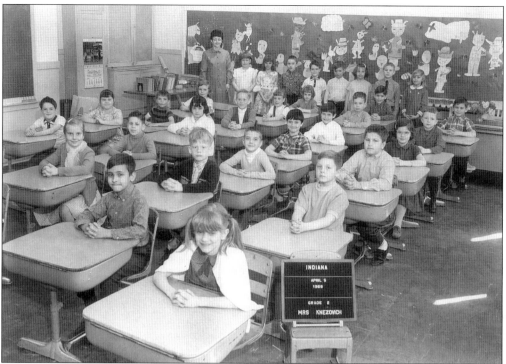

The Indiana Avenue School was demolished in 1970. This April 1968 image shows Mrs. Knezovich's second grade class during the school's last years in existence. Some of the students in this photo are Rich Nelson, George Trobejic, Jeff Daniels, and Ken Pitchfortd. (Photograph courtesy of the Lansing Historical Society.)

This graduation photo from the University of Viriginia is of Ruth Hale Canaga, former teacher at Thornton Fractional High School for over 30 years. This image is c. 1910 (Photograph courtesy of the Lansing Historical Society.)

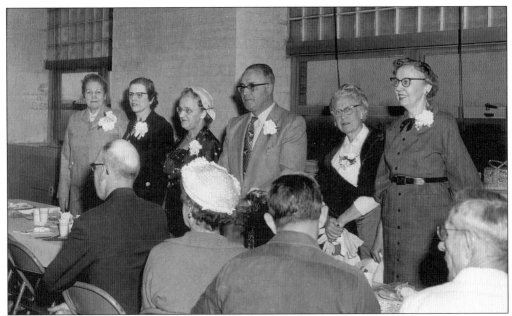

On April 4, 1957, these six teachers were recognized by the National Education Association for their years of service in the Lansing schools. They are, from left to right: Mrs. Fullers, Miss Van Weelden, Mrs. Gyte, Mr. Farley, Mrs. Bouton, and Mrs. Peters. (Photograph courtesy of the Lansing Historical Society.)

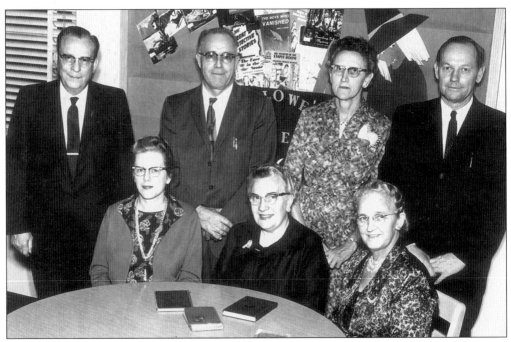

At this 1961 National Educational Association celebration, these teachers were recognized for their combined total of over 250 years of service. They are, from left to right: (standing) Mr. Crawl (37 years), Mr. Farley (34 years), Miss Whiteman (38 years), Mr. Damron (32 years); (seated) Miss Van Weelden (34 years), Ms. Tatro (41 years), and Mrs. Gyte (38 years).

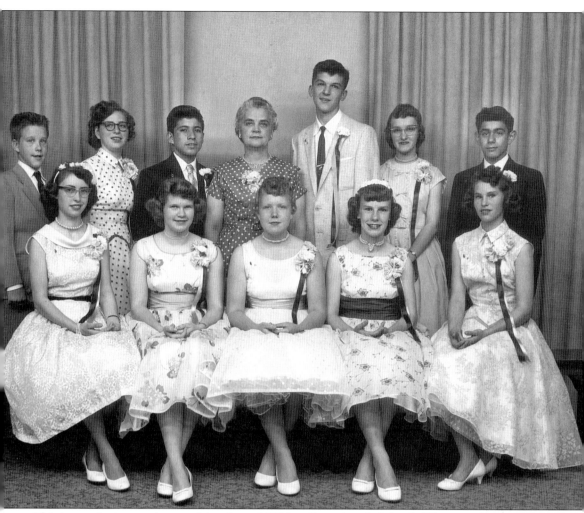

This image depicts graduates of the class of 1954 at Sunnybrook School. (Photograph courtesy of the Lansing Historical Society.)

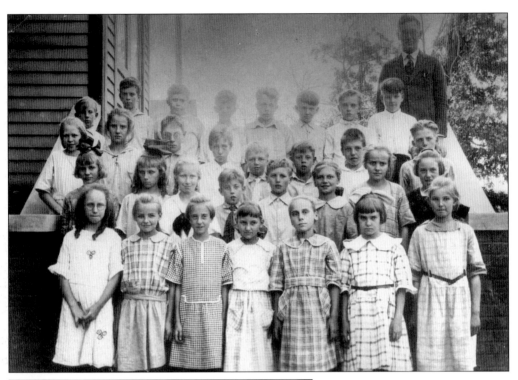

Mr. John Huizenga's class at the Munster Christian School is pictured in 1921. (Photograph courtesy of the Lansing Historical Society.)

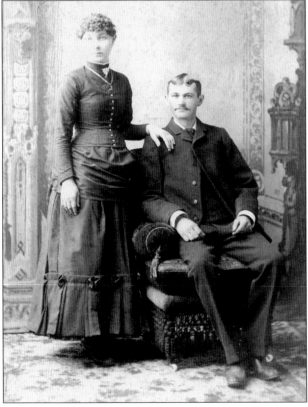

Indiana Avenue School janitor Simon Hanks and his wife are pictured here. He was well liked by the students, who called him "Hookey." (Photograph courtesy of the Lansing Historical Society.)

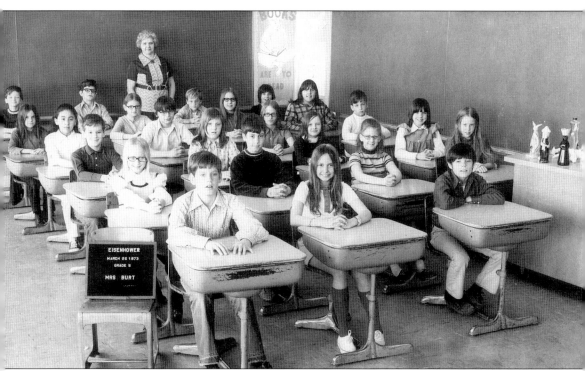

The Eisenhower School was built in 1953, to relieve school crowding after the post-war baby boom. Construction on the school was completed in only 180 days, and it was the first school in the nation to be named after newly elected President Dwight D. Eisenhower. Pictured is Mrs. Burt's fifth grade class in March of 1973. (Photograph courtesy of the Lansing Historical Society.)

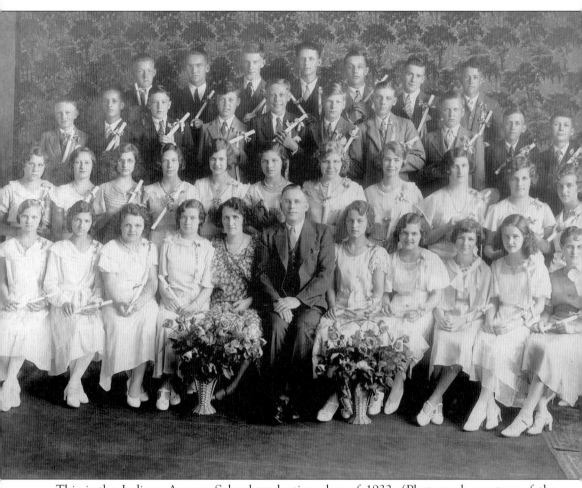

This is the Indiana Avenue School graduating class of 1932. (Photograph courtesy of the Lansing Historical Society.)

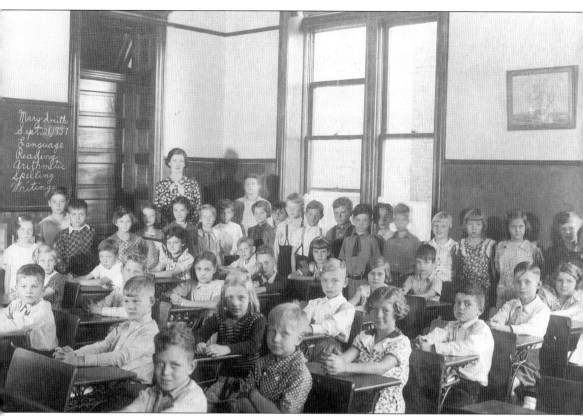

Students in Mary Smith's third grade class at the Indiana Avenue School in 1938 sit seriously with hands folded for a class photo. (Photograph courtesy of the Lansing Historical Society.)

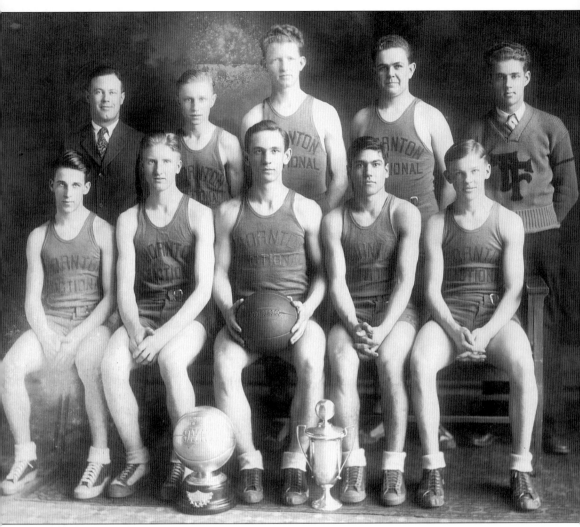

Pictured is the 1927–28 Thornton Fractional basketball team. They are, from left to right: (seated) Joe Wilhelm, Tibby Fieldhouse, Capt. Pete Stralko, Carl Sacco, John Tomkutonis; (standing) Coach Wilbur Petree, Harry Zaleta, Ed Fitzgerald, Cecil Buckman, and Leo Friedman. (Photograph courtesy of the Lansing Historical Society.)

Three
CHURCHES

Lansing's first church was started in 1861, after Gerrit Eenigenburg purchased a little over 2 acres of land from John and Louise Lansing for $40 for the North Creek of Thornton Holland Reformed Church and burial ground. By 1873, many members had left to join a Munster, Indiana, church, causing the Lansing church to close. In 1875, it reopened as the Reformed Church of Lansing, later becoming the First Reformed Church of Lansing. The congregation grew over the years and many additions were made. Services were held entirely in Dutch until an English service was added in 1918, and the last Dutch service was held in 1942. In January 1945, the church was destroyed by fire. A new structure was soon rebuilt on the same grounds.

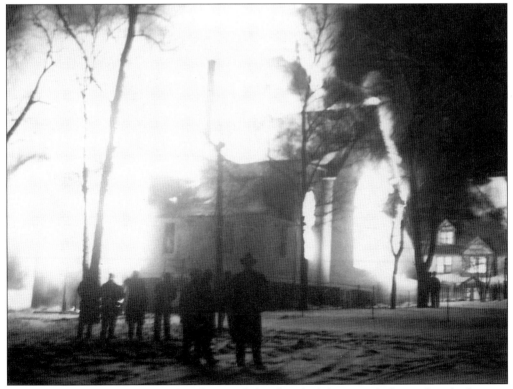

Pictured is the devastating fire that destroyed the church. (Photograph donated to the Lansing Historical Society by the Boender family.)

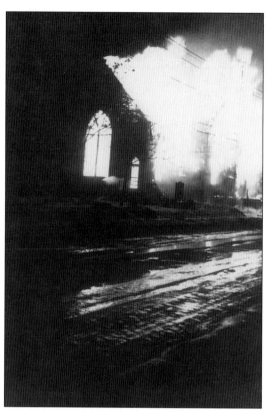

This is another view of the First Reformed Church fire in 1945. (Photograph donated to the Lansing Historical Society by the Boender family.)

The original First Reformed Church of Lansing is shown here before it was destroyed by fire. (Photograph donated to the Lansing Historical Society by the Boender family.)

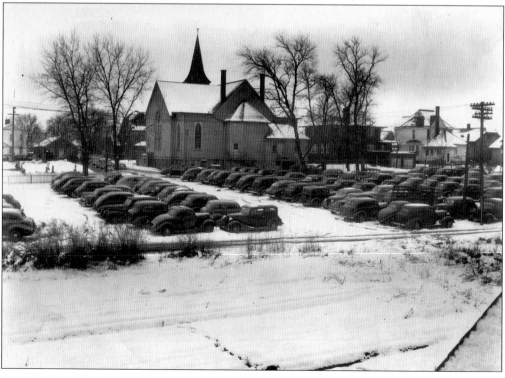

The Trinity Evangelical Lutheran Church is located in what was then Oak Glen, Illinois, on Indiana Avenue. (Photograph courtesy of the Lansing Historical Society.)

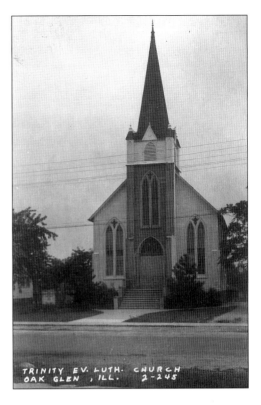

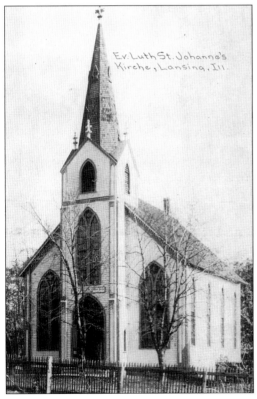

The original St. John's Lutheran Church was built in 1883. (Photograph courtesy of the Lansing Historical Society.)

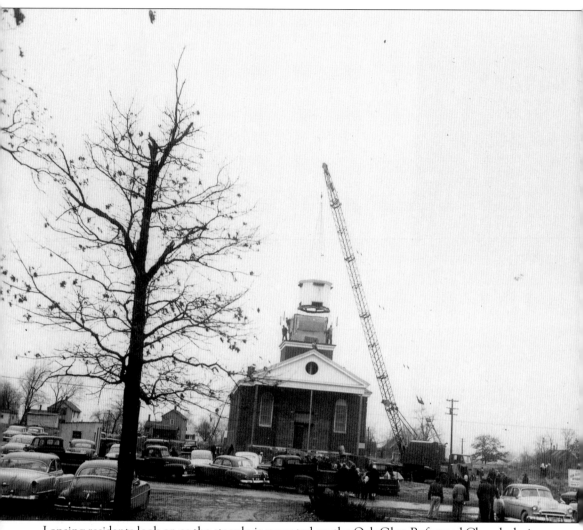

Lansing residents look on as the steeple is mounted on the Oak Glen Reformed Church during construction. (Photograph courtesy of the Lansing Historical Society.)

Four

PEOPLE, PLACES, AND SOCIAL EVENTS

"When I moved here as a child, Lansing was known for its good schools, many churches, clubs, service organizations, emergency services, and its friendly people. Forty-five years later, I've witnessed all this to be true—and more."

—Tom Coster

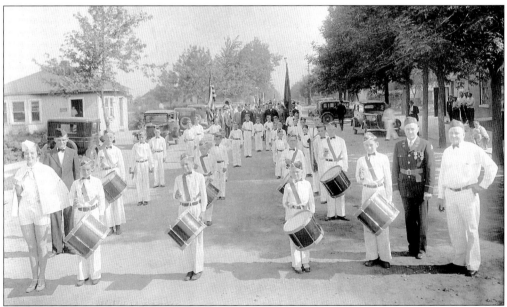

Lansing American Legion Post 697's Drum and Bugle Corps, organized in 1931, perform in this 1934 parade down Henry Street. According to a community project and contribution report of 1973, some of the commitments of the American Legion Post listed were to sponsor Boy Scout Troop 526, to contribute to the community chest and the American Red Cross, to supply wreaths for Memorial Day ceremonies, and to sponsor an essay contest at Memorial Junior High School. (Photograph courtesy of the Lansing Historical Society.)

Many former students of Thornton Fractional High School will remember American History teacher Ruth Hale Canaga. A descendant of Nathan Hale, Ms. Canaga spent over 30 years teaching at Thornton Fractional High School in Calumet City. Pictured is her home in Lansing at 3151 Ridge Road. (Photograph courtesy of the Lansing Historical Society.)

The Canaga home was demolished in the 1970s. The Ameritech building now stands on the site where the home was located. (Photograph courtesy of the Lansing Historical Society.)

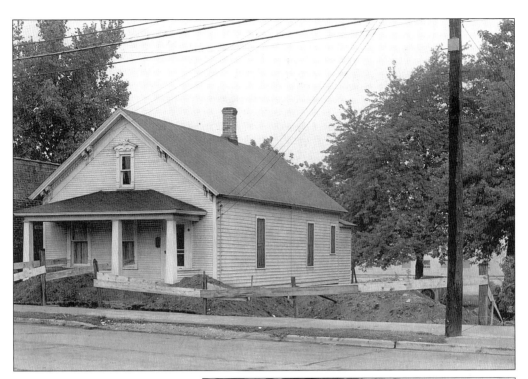

This home on Ridge Road once belonged to Evert C. Schultz. An upholster by profession, Mr. Schultz was also very active in the community, joining the Lansing Fire Department in 1938, serving as a Thornton Township Committeeman, and later as mayor of Lansing. (Photograph courtesy of the Lansing Historical Society.)

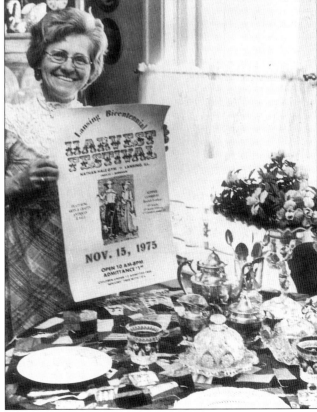

Shirley Hamilton proudly displays a sign advertising an antique show held at the Nathan Hale Gymnasium on November 15, 1975.

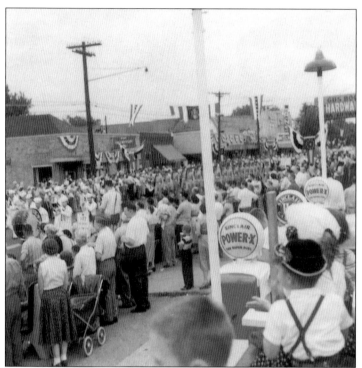

This photo was taken at the centennial parade in 1954. (Photograph courtesy of the Lansing Historical Society.)

Mayor Evert Schultz poses with Sharon Lang, Centennial Queen, and members of the court. (Photograph courtesy of the Lansing Historical Society.)

Ruth Rasmussen served as the village clerk for 16 years. (Photograph courtesy of the Lansing Historical Society.)

Some young Lansing men sit on the window ledge of the Lansing State Bank in this photograph. The building still stands on Ridge Road and is currently operating as the offices of H&R Block. (Photograph courtesy of the Lansing Historical Society.)

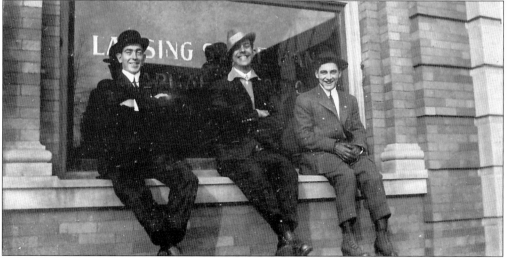

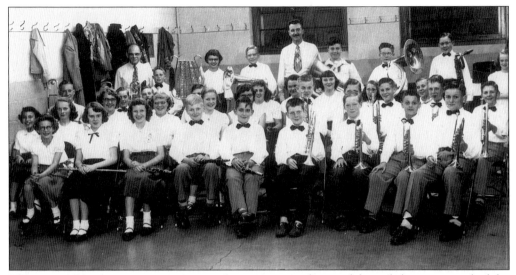

The year 1954 was an important one in Lansing, as residents celebrated the centennial of the village's first 100 years. Here a school band is dressed up to perform for the event. (Photograph courtesy of the Lansing Historical Society.)

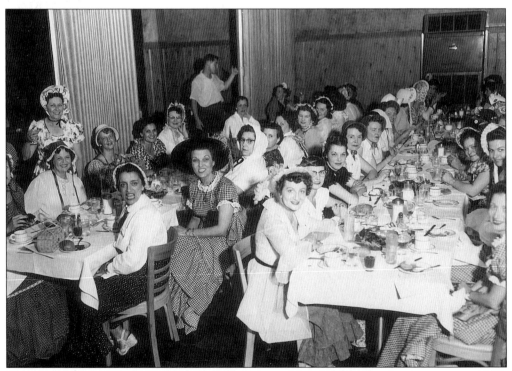

A group of Lansing ladies celebrates the centennial by dressing for the occasion in 1800s clothing.

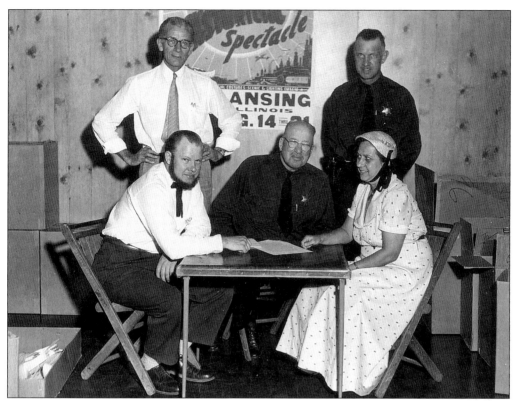

The Hospitality Committee of the 1954 Centennial included Police Chief Van Laningham (seated, middle). (Photograph courtesy of the Lansing Historical Society.)

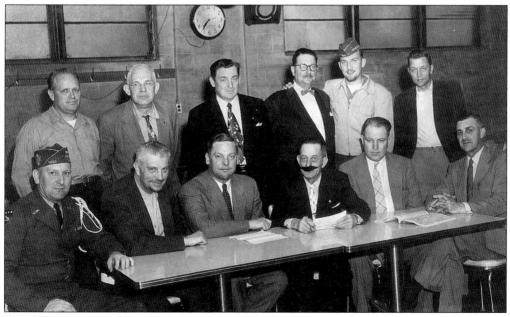

The 1954 Centennial Parade Committee met at the American Legion. (Photograph courtesy of the Lansing Historical Society.)

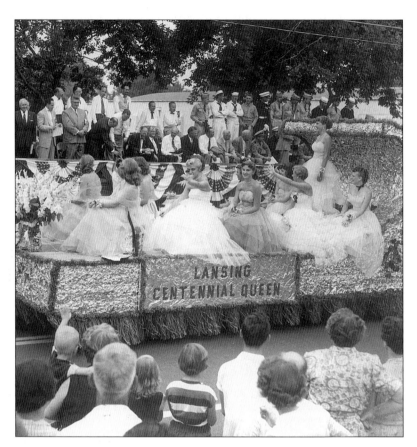

The Centennial Parade was a huge event. Pictured is the Lansing Centennial Queen and her court. (Photograph courtesy of the Lansing Historical Society.)

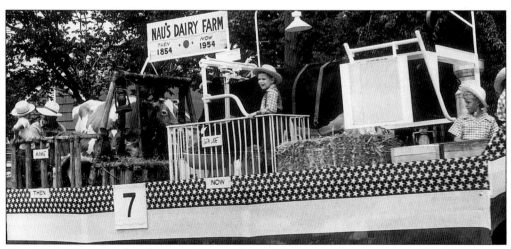

Nau's Dairy Farm had a float in the parade, which included a live cow, advertising their business. (Photograph courtesy of the Lansing Historical Society.)

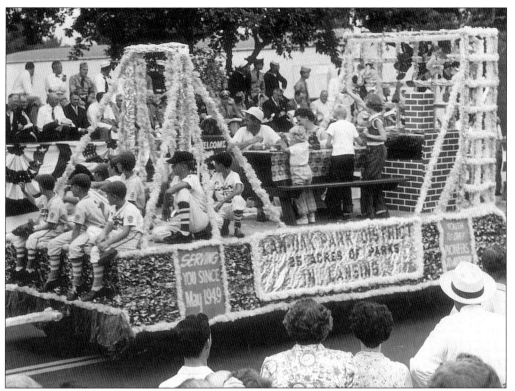

Young baseball players wave from the float celebrating the Lan-Oak Park District. (Photograph courtesy of the Lansing Historical Society.)

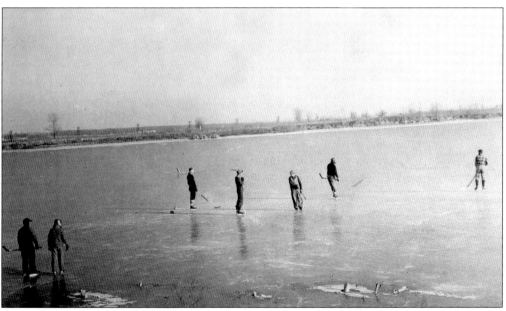

In 1940, playing ice hockey at the old clay hole at 186th and Wentworth was a popular pastime. The "old clay hole" is now a private lake of the Lansing Country Club. (Photograph courtesy of the Lansing Historical Society.)

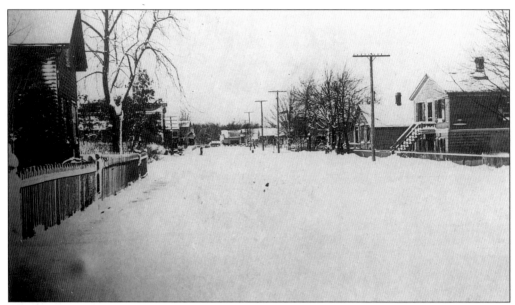

The Chicago area saw some harsh winters in the late 1960s. Without the snowplow equipment we have today, snow removal was a much more involved process. The snow on this Lansing street sits untouched after a March 1968 snowfall. (Photograph courtesy of the Lansing Historical Society.)

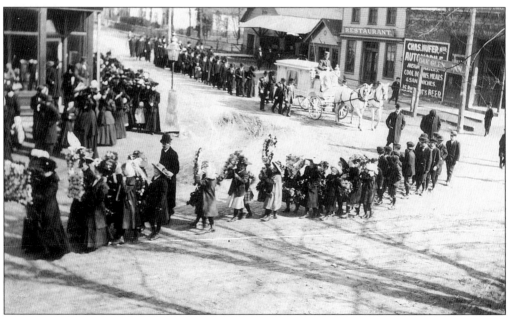

This procession of Oak Glen residents appears to be a funeral procession, likely heading for the Oak Glen Lutheran Cemetery between Indiana Avenue and what is now Thornton-Lansing Road. (Photograph courtesy of the Lansing Historical Society.)

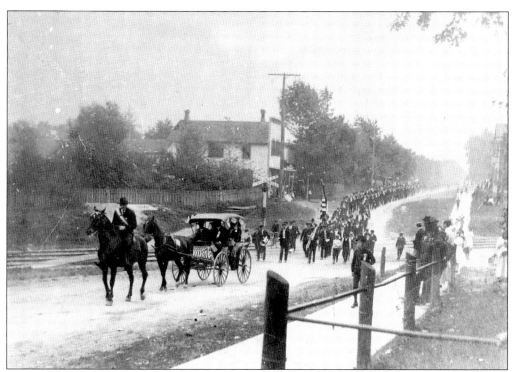

Parades in Lansing have always attracted large numbers of participants and spectators, as did this 1904 Labor Day Parade. (Photograph courtesy of the Lansing Historical Society.)

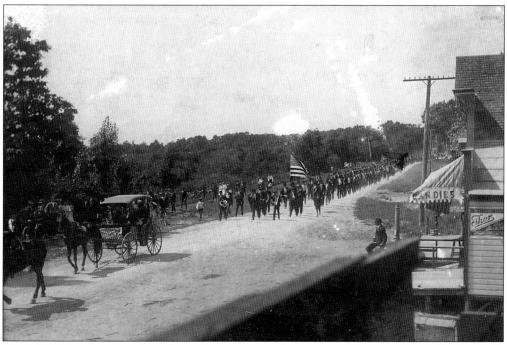

The 1904 Labor Day Parade is shown here from another spot on the parade route. (Photograph courtesy of the Lansing Historical Society.)

This building stood just east of the Pennsylvania Railroad on Ridge Road. This photo was taken on Christmas Eve in 1914. (Photograph courtesy of the Lansing Historical Society.)

This facility now serves as the office of the mayor and village clerk. (Photograph courtesy of the Lansing Historical Society.)

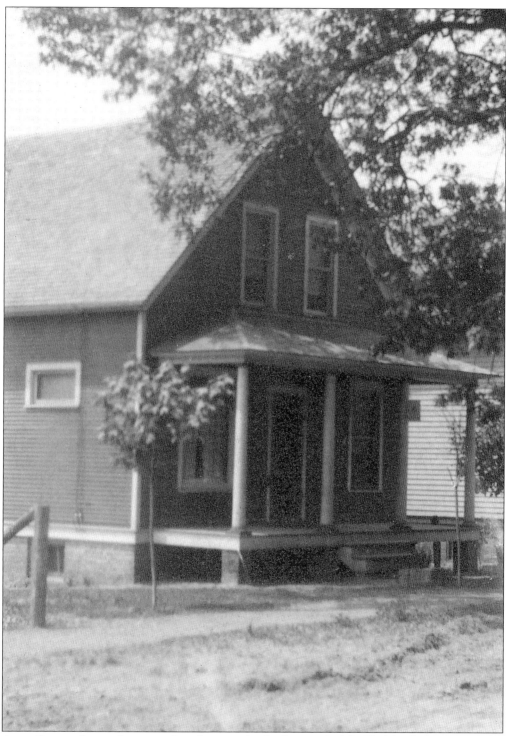

According to the markings on this photograph, the home of a Mr. Highland at 2745 Indiana Avenue was the location of the first telephone exchange in town in June of 1915. (Photograph courtesy of the Lansing Historical Society.)

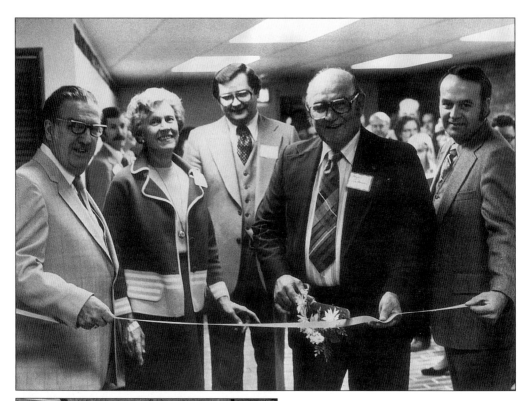

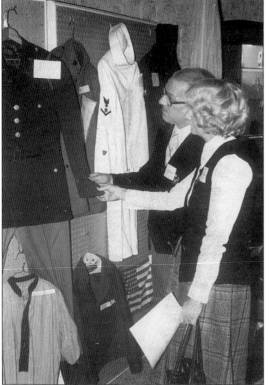

Village officials cut the ribbon at the new Lansing Historical Society Museum in 1980. This site in the lower level of the Lansing Public Library became the permanent home of the museum after being housed in a room on an upper level of a Lansing bank for four years. (Photograph courtesy of the Lansing Historical Society.)

Military uniforms made up one of the exhibits of the new museum facility. (Photograph courtesy of the Lansing Historical Society.)

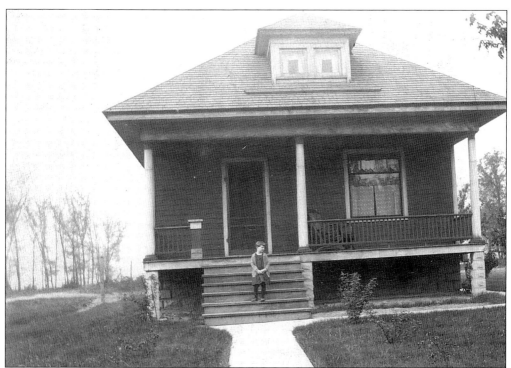

One of the Ward children sits on the porch of the family home at the corner of Oakley and Ridge Road in the 1920s. The home still stands at that location, although it has had extensive remodeling and hardly resembles the home in this photo. (Photograph courtesy of the Lansing Historical Society.)

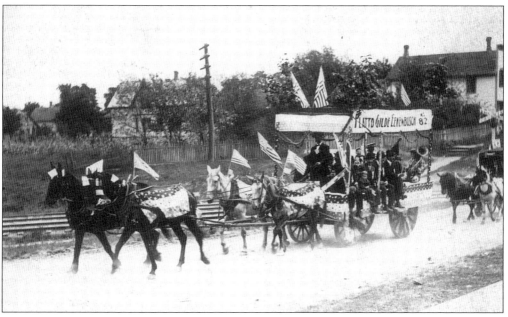

An early horse-drawn parade wagon displays signs for election candidates. (Photograph courtesy of the Lansing Historical Society.)

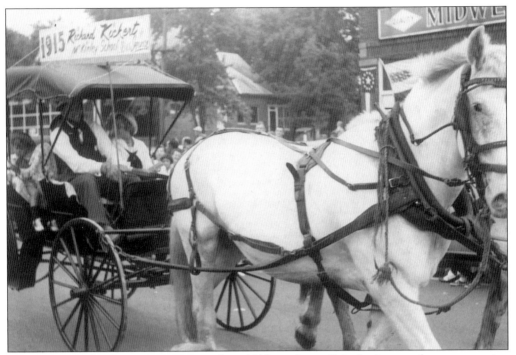

The Kickert School Bus Service started in 1915, and is still in business today, transporting students of the Lansing schools. The first school buses used by the company were actually wagons, such as the one displayed here in the 1954 Centennial Parade. (Photograph courtesy of the Lansing Historical Society.)

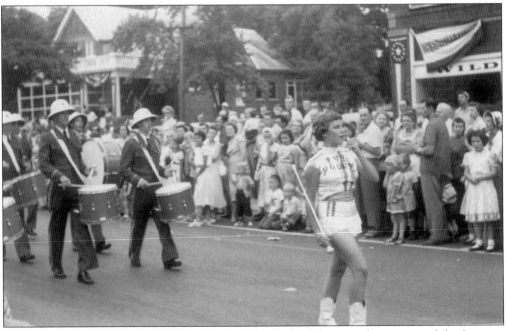

A youth band performs in the 1954 Centennial Parade. (Photograph courtesy of the Lansing Historical Society.)

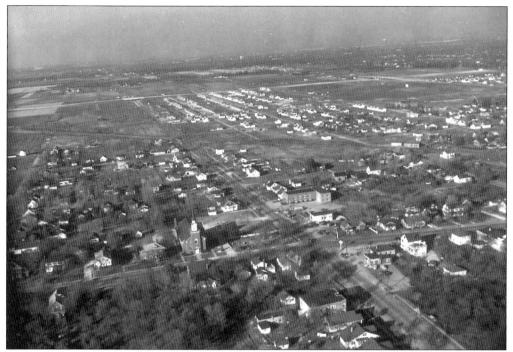

In this aerial photo of Lansing, it is apparent how the village has changed in recent years. This is the intersection of Burnham Avenue and Ridge Road looking north. The Reformed Church and cemetery are shown at the northwest corner. (Photograph courtesy of the Lansing Historical Society.)

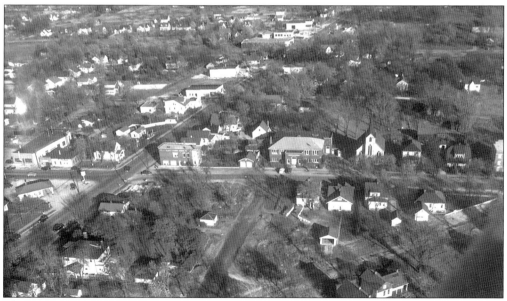

This image shows an aerial view of Ridge Road looking east at Wentworth Avenue. The only corner structure still standing is the building which houses Char's Bridal Shop on the southeast corner. Just south of that building you can see the old St. John's Lutheran Church and School. (Photograph courtesy of the Lansing Historical Society.)

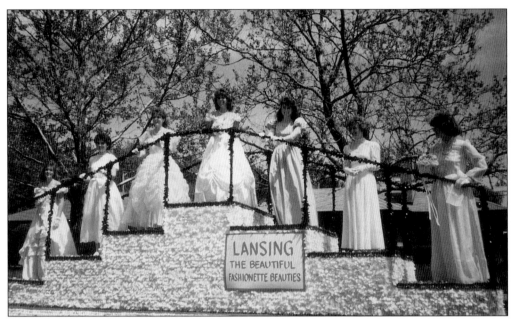

For over 50 years, the first Saturday in May has been a significant date in Lansing. Each year, thousands of residents gather to participate in or to simply watch the Good Neighbor Day Parade. In the 1985 Good Neighbor Parade, these teens dressed in their formal gowns for the Fashionette float. (Photograph courtesy of Jackie Protsman.)

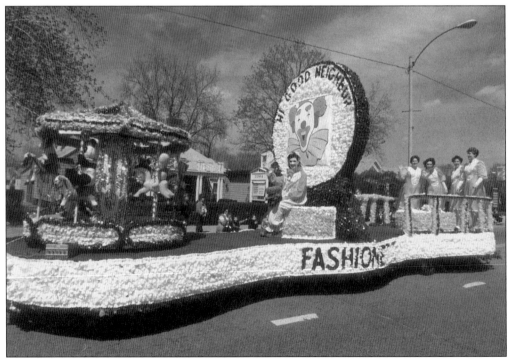

The Fashionette often decorated elaborate floats to celebrate Good Neighbor Day. (Photograph courtesy of Jackie Protsman.)

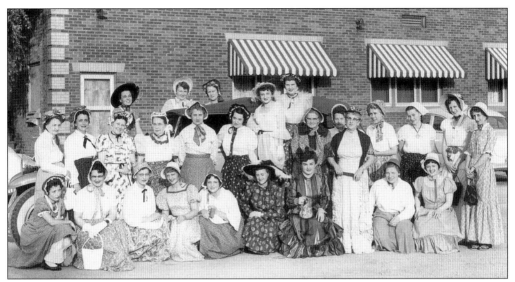

The women of the Lansing Garden Club made many efforts to beautify the area. Among their early projects, after organizing in June of 1951, were planting magnolia trees in Lan-Oak Park, passing out litter bags at the Good Neighbor Day Parade, planting evergreens at Village Hall, and donating money to landscape the Harvey toll plaza. (Photograph courtesy of the Lansing Historical Society.)

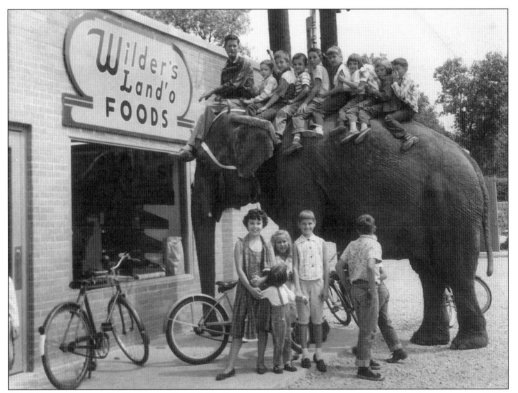

Children ride an elephant at the 1954 Centennial Celebration. (Photograph courtesy of the Lansing Historical Society.)

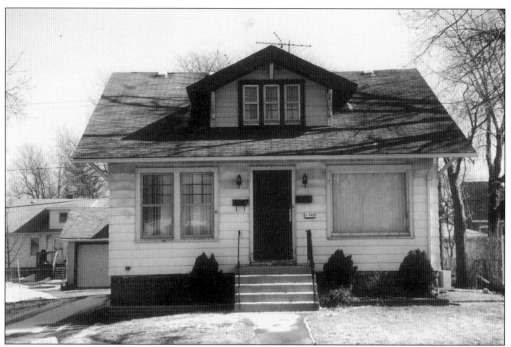

Between about 1907 and 1930, Sears, Roebuck & Company offered several home models for sale though their catalog. Several Lansing homes were purchased in kits from the catalog, such as the one pictured here. (Photograph by Maxine Olsen.)

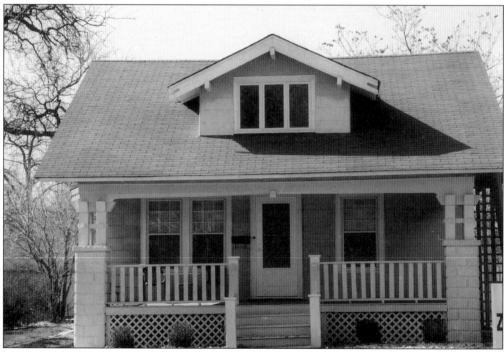

Many catalog homes included large porches, which extended across the entire front of the home—including the Lansing home pictured here. (Photograph by Maxine Olsen.)

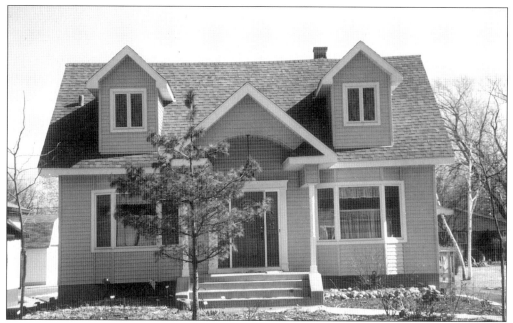

This home on Chicago Avenue, also purchased through the Sears catalog, has undergone remodeling in recent years to include new gray siding with a red door. (Photograph by Maxine Olsen.)

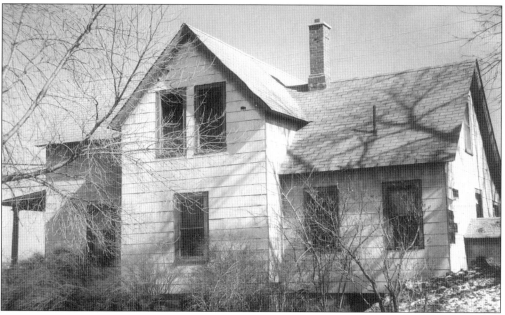

This Sears catalog home was owned by the Eenigenburg family. The home was built in 1911 or 1912. According to Cornelius Eenigenburg, who along with his brothers and sisters was born in the home, says that the original plans for the home included a bathroom. However, "that was for city folks," he says. The bathroom space was used for a pantry. This home stands at the corner of Thornton-Lansing Road and Burnham Avenue. It is scheduled for demolition in late 2001. (Photograph by Maxine Olsen.)

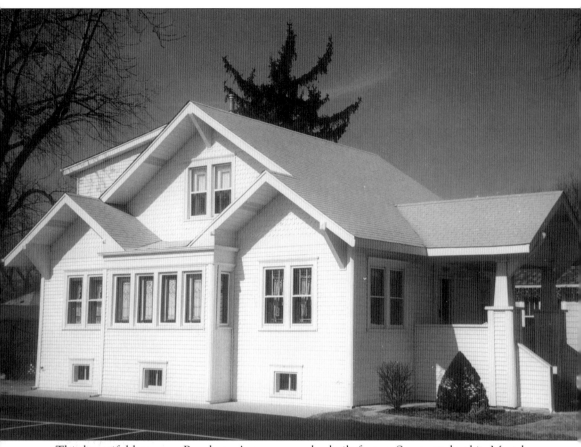

This beautiful home on Burnham Avenue was also built from a Sears catalog kit. Most homes arrived in two full boxcars by train with around 40,000 labeled individual pieces. This home is located just north of the Lansing Reformed Church. (Photograph by Maxine Olsen.)

Five

LANSING FIRE DEPARTMENT

"The Lansing Firefighters pledge their best efforts for the preservation of life and property to the people in our community."

—Lansing Firefighter's Pledge.

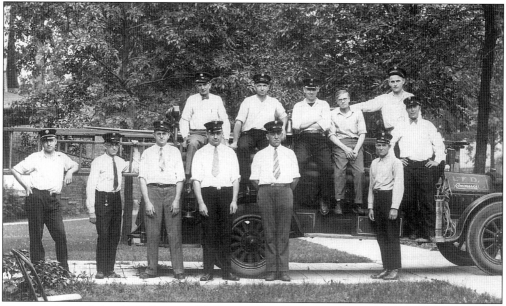

The members of the 1927 Lansing Volunteer Fire Department are pictured with their first actual fire truck, a 1922 commerce, 250 gallon-per-minute pumper. They are, from left to right: (standing) Gerald Wright, Tony Koselke, Bill Erfert, Walter Kegebein, George Dockweiler, Al Heintz; (on truck) Clarence Kemp, George Rhoda, Frank LaSalle, Paul Sass, Howard Clark, and Pete Busch.

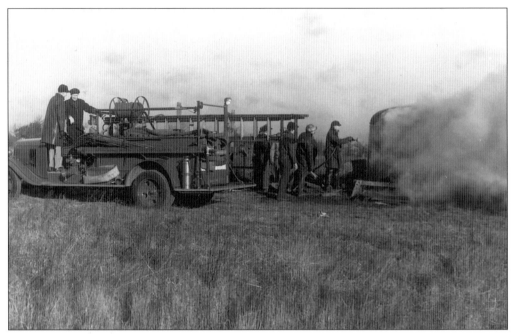

There have been drastic improvements over the years in firefighting equipment. Here Lansing firefighters work to extinguish a fire. Notice that the protective gear is limited to a rubber coat and boots. (Photograph courtesy of the Lansing Historical Society.)

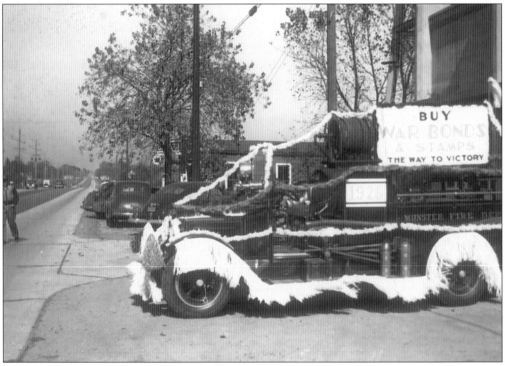

An engine from the bordering town of Munster is prepared for a parade during World War II. (Photograph courtesy of the Lansing Historical Society.)

A Lansing pumper is used to supply water for a fire at this restaurant/tavern. (Photograph courtesy of the Lansing Historical Society.)

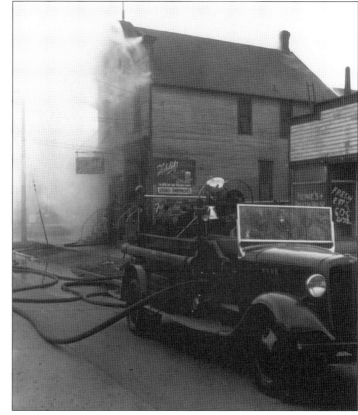

Here is the same pumper as it appears today, known as "Old 104." It is used in the Good Neighbor Day parade and during fire prevention week to give rides to children. (Photograph by Carrie Steinweg.)

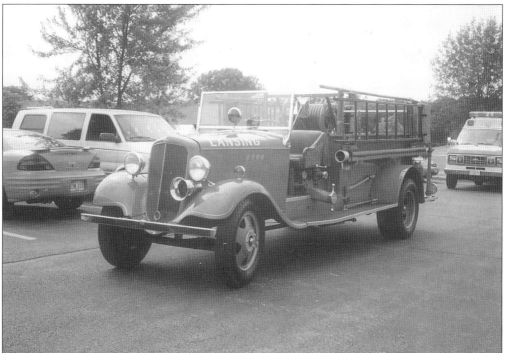

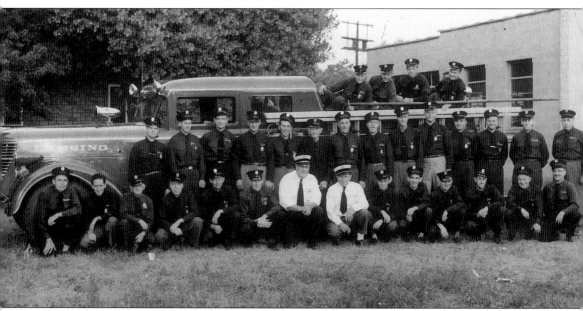

Members of the 1952 Lansing Volunteer Fire Department are gathered for a photo. Pictured here, from left to right, are: (bottom row) Milton Schultz, Roy Huitema, John Koenes, Marty Depoutee, Conrad Gleim, Frank LaSalle, Bill Winterhoff, Evert Schultz, Ralph Schauer, Frank Novak, George Tates, Phil Morris, Russell Twait, Orville Grieder; (row 2) Herman Van Zyl, John Demik, Tony Hoekstra, Andy Delaurentis, Charles Hendricks, Al Heintz, Louis Campagna, Richard Rosenno, Ed Sissel, Clarence DeValk, Ray Wishart, Howard Wetmore, Ervin Vonbohrn, Herman Mueller; (row 3) Jim Koselke, Charles Yates, Richard Babbitt, and Ray Lawrence. (Photograph courtesy of the Lansing Historical Society.)

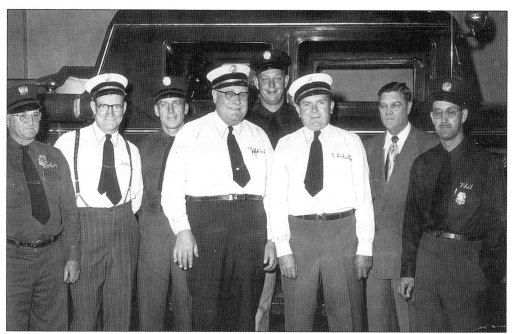

Officers of the Lansing Fire Department pose for a photo. (Photograph courtesy of the Lansing Historical Society.)

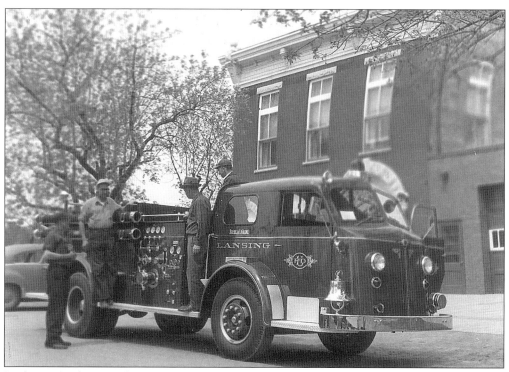

In this 1954 photograph, a Lansing fire engine sits in front of the original fire station, which is still in use today as fire station #1 of the four stations within the village. (Photograph courtesy of the Lansing Historical Society.)

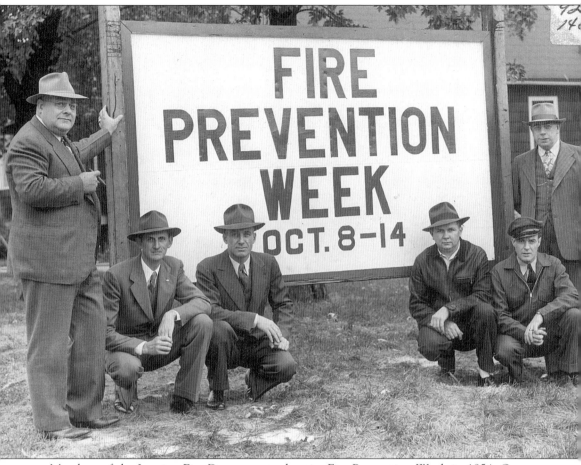

Members of the Lansing Fire Department advertise Fire Prevention Week in 1954. One year later, the Lansing Fire Prevention Bureau was formed. Pictured from left to right are: "Big Bill" Winterhoff, Art Krumm, Erwin Van Behren, Evert Schultz, Walter Rahn, and Herman Mueller. (Photograph courtesy of the Lansing Historical Society.)

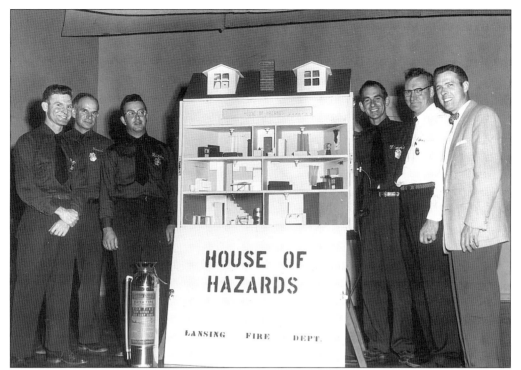

In 1956, the "House of Hazards" was built by firemen of the Lansing Fire Department to be used as an educational tool for demonstrations at schools and churches. Pictured from left to right are: George Yates, Paul Scarlett, Richard Bertela, Frank Novak, Chief Schultz, and William LaMonte. (Photograph courtesy of the Lansing Historical Society.)

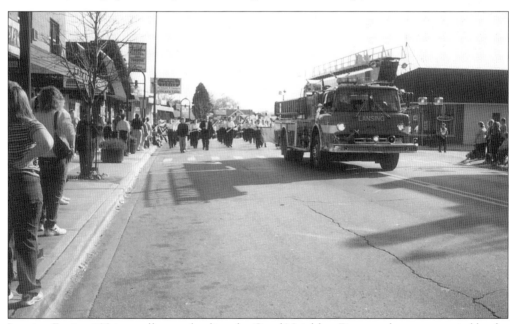

Lansing Engine 102 is usually seen leading the Good Neighbor Day parade, accompanied by the department's other apparatus. (Photograph courtesy of Jackie Protsman.)

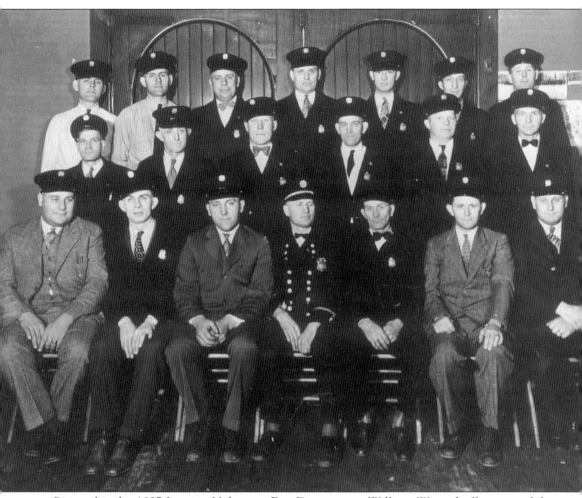

Pictured is the 1927 Lansing Volunteer Fire Department. William Winterhoff, owner of the Winterhoff Ford Agency, donated a flatbed truck that had a tank and hose installed—that became Lansing's first fire truck. Winterhoff served as the fire chief from 1922–29, and continued to serve on the fire department until his death in 1973. The Lansing Fire Department began with nearly 60 men, but a year later only 26 men made up the department. Pictured here, from left to right, are: (row 1) Bill Winterhoff, Henry Schultz, George Dockweiler, Gerald Wright, Clarence "Pep" Kemp, Bill Erfert, Walter Winterhoff; (row 2) Paul Sass, Tony Koselke, Pete Busch, Al Kemp, Whitey Hecht, George Rhoda; (row 3) Harold Clark, Howard Clark, Herman Mueller, Walt Kegebein, Fritz Vierk, Bill Hecht, and Frank LaSalle. (Photograph courtesy of the Lansing Historical Society.)

Six

BERNICE, OAK GLEN, AND LANSING

"Growing up in Oak Glen in the 1950s was special for me. In the '50s, it was still known as Oak Glen by those who lived there. I lived in a big old farmhouse set back in the wood south of the railroad tracks on Torrence Avenue. As a teen I worked on Torrence at the A&W Root Beer Stand (now Golden Crown Restaurant) as a carhop. It was a fun job."

—Jeanette Voegerl Cobb.

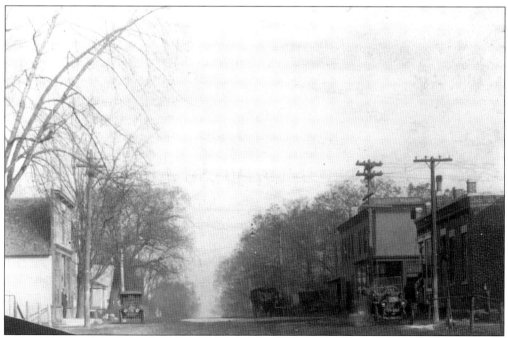

The main area of the town of Oak Glen was around what is now Torrence Avenue and Indiana Avenue. Here is a view of Yates Avenue (now Torrence Avenue) looking north. (Photograph courtesy of the Lansing Historical Society.)

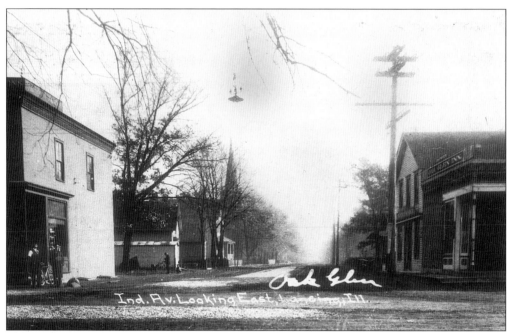

Here is the intersection of Indiana Avenue and Yates Avenue (Torrence Avenue) looking east on Indiana Avenue. On the left, the steeple of the old Trinity Lutheran Church can be seen. (Photograph courtesy of the Lansing Historical Society.)

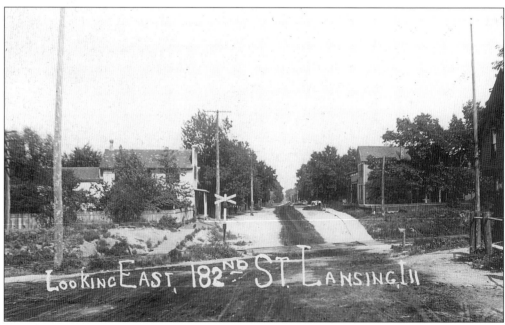

Pictured here is 182nd Avenue (Ridge Road) looking east. (Photograph courtesy of the Lansing Historical Society.)

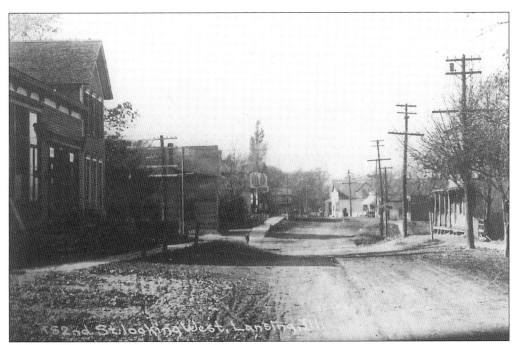

This image shows the Pennsylvania Railroad crossing on 182nd Street (Ridge Road) looking east. (Photograph courtesy of the Lansing Historical Society.)

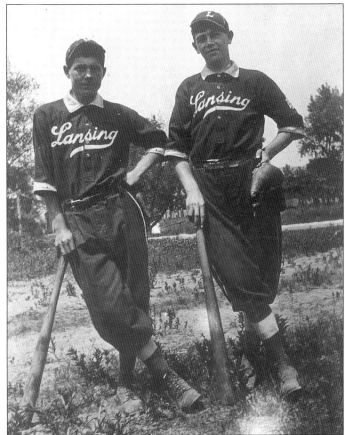

Baseball has always been a popular sport in Lansing. In the early days, each community had their own baseball team, and many games were played in a field behind Busak's Tavern on Ridge Road. The building which was once Busak's Tavern still stands on Ridge Road. Pictured are some players of the Lansing baseball team. (Photograph courtesy of the Lansing Historical Society.)

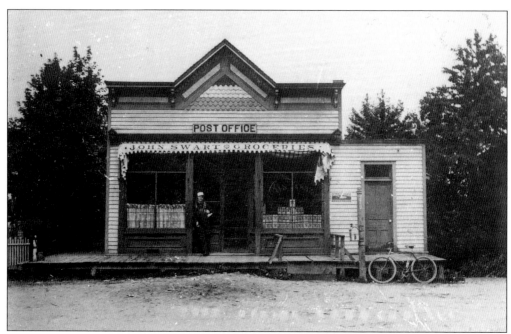

Oak Glen had its own post office which later became a branch of the Lansing Post Office. Pictured here is the spot that once served as Lansing's Post Office, John Swart Groceries. (Photograph courtesy of the Lansing Historical Society.)

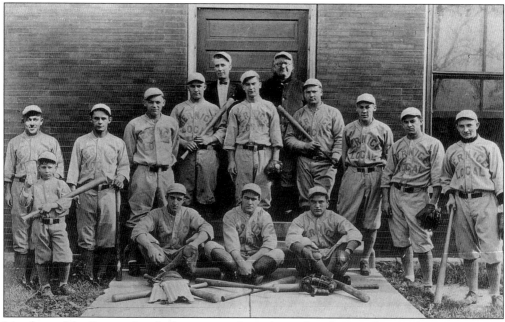

Members of the Bernice baseball team pose for a photo. Standing in the rear (not in uniform) are coaches Jack Reed Sr. and Al Kindt Sr. Some of the players standing from left to right are: Benny Vierk, "Butch" Ed Horn, Melvin (Buke) Vierk, Martin Lange, Joe Drunecke, Bill Fiene. The boy at left is Sonny Reed. Seated is Bill Hecht and two unidentified individuals. (Photograph courtesy of the Lansing Historical Society.)

Seven

LANSING AIRPORT

The Lansing Airport first came to be when Henry Ford purchased land at what is now Burnham Avenue and Glenwood-Lansing Road, previously farmland owned by the Fisher Estate of Chicago, which was rented to local farmers. The Ford Airport was built as a facility where his parts could be flown from Michigan and transported to the Ford Automobile Plant in Chicago's Hegewisch neighborhood. It later became know as the Chicago Hammond Airport. Today, the facility is known as the Lansing Municipal Airport, and it has expanded greatly to accommodate small planes.

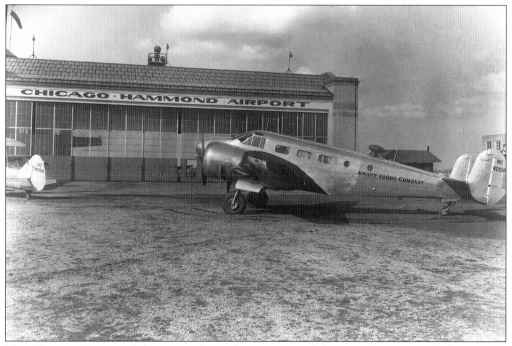

The Chicago-Hammond Airport is shown here in 1927. (Photograph courtesy of the Lansing Historical Society.)

The Ford Motor Plant in Hegewisch, pictured here, was the reason for the construction of the Ford Airport. (Photograph courtesy of the Lansing Historical Society.)

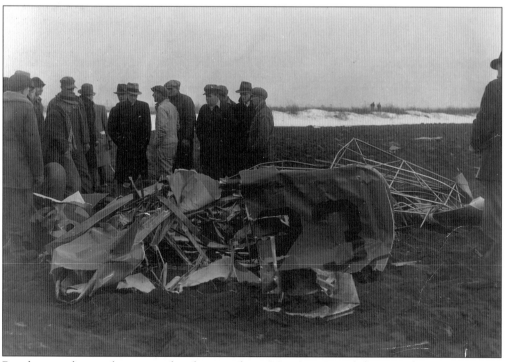

Residents gather at the scene of a plane crash on May 31, 1949. (Photograph courtesy of the Lansing Historical Society.)

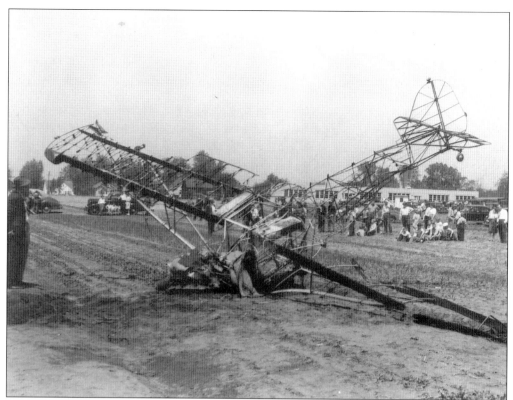

Years ago, air travel was not nearly as safe as it is today. This image depicts yet another plane crash in Lansing. (Photograph courtesy of the Lansing Historical Society.)

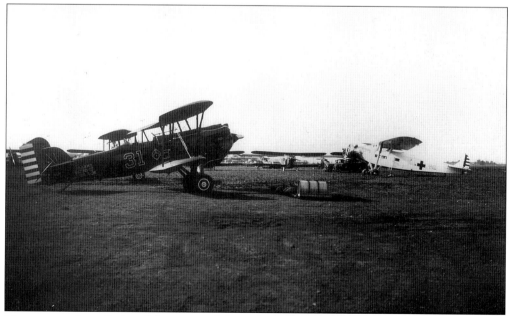

Many types of small aircraft have passed through the airport over the years. One of the planes in this photo is a medical aircraft. (Photograph courtesy of the Lansing Historical Society.)

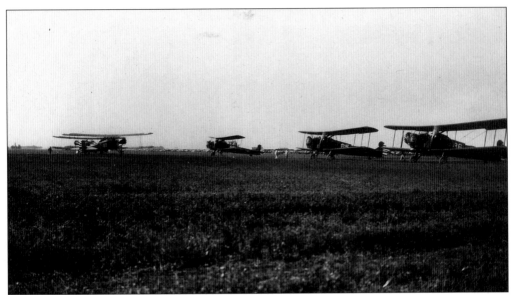

Small planes line up in the field at the Chicago Hammond Airport. (Photograph courtesy of the Lansing Historical Society.)

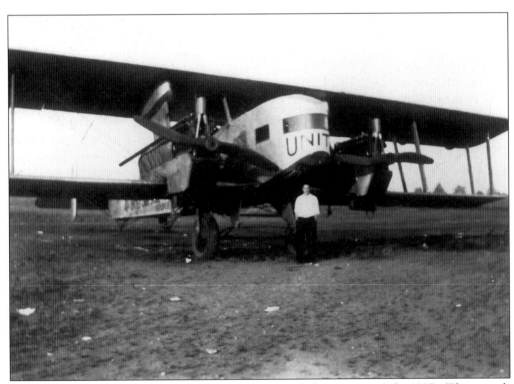

A pilot poses with his plane at the Chicago Hammond Airport in July 1927. (Photograph courtesy of the Lansing Historical Society.)

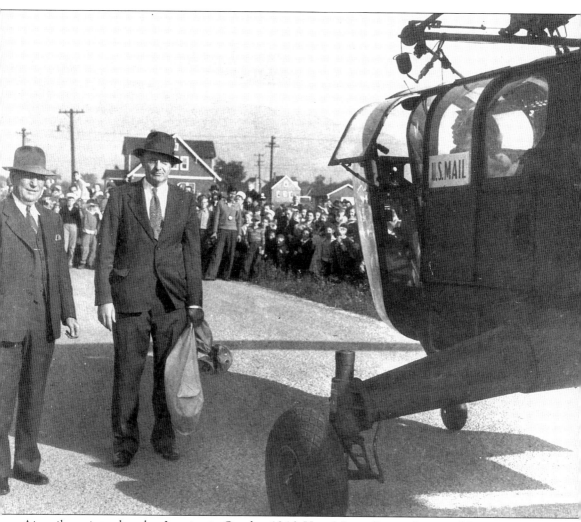

Airmail was introduced to Lansing in October 1946. Here Mayor George Jones and Postmaster William Erfert stand on Madison Street between William Street and Wentworth Avenue for the first helicopter pick up. (Photograph courtesy of the Lansing Historical Society.)

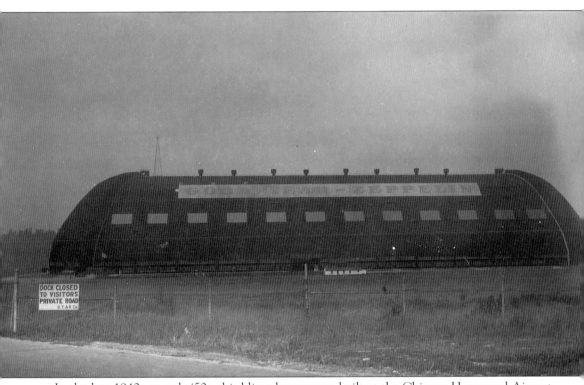

In the late 1940s or early '50s, this blimp hanger was built at the Chicago-Hammond Airport. (Photograph courtesy of the Lansing Historical Society.)

Eight
LANSING BUSINESS

"I really love what I do and hope to continue doing it for a while. Lansing is a great place to live!"
—Jackie Protsman, owner of the Fashionette.

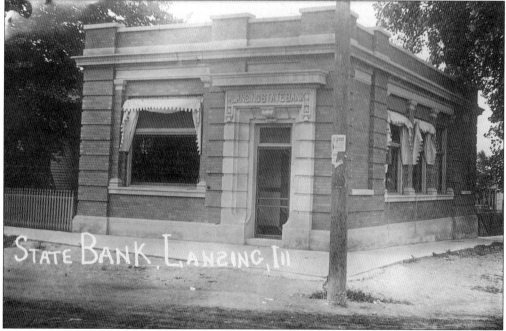

Lansing's first bank, the Lansing State Bank, is pictured here. The building still stands on Ridge Road and has most recently been used as the offices of a tax service. (Photograph courtesy of the Lansing Historical Society.)

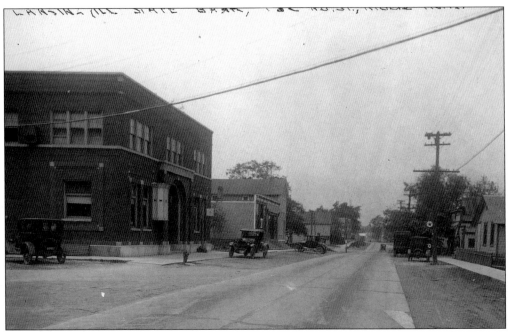

This building on Ridge Road housed the Lansing State Bank at one time. (Photograph courtesy of the Lansing Historical Society.)

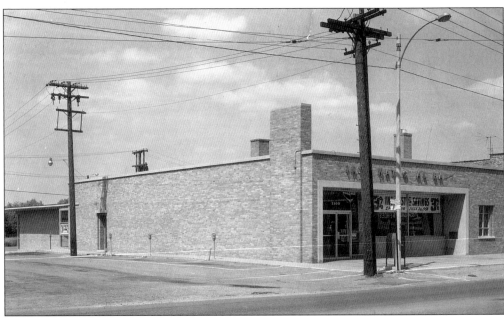

The building at the northeast corner of Ridge Road and Roy Street was once the First National Bank of Lansing. The front portion of the building is now Mancino's Restaurant. Notice the field behind the building, which is the site of the current post office. (Photograph courtesy of the Lansing Historical Society.)

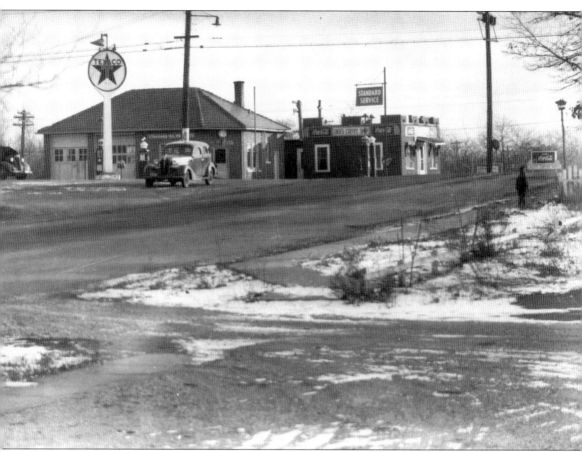

Service stations were once familiar sites along Ridge Road and Torrence Avenue in Lansing, as was this Texaco Station situated beside Dick's Coffee Shop. Today, the fact that gas prices are lower down the street in the state of Indiana and the enormous cost associated with replacing equipment to meet new federal regulations have made it difficult for many gas stations to remain in business. Only four gas stations remain in Lansing, all on Torrence Avenue near Interstate 80. (Photograph courtesy of the Lansing Historical Society.)

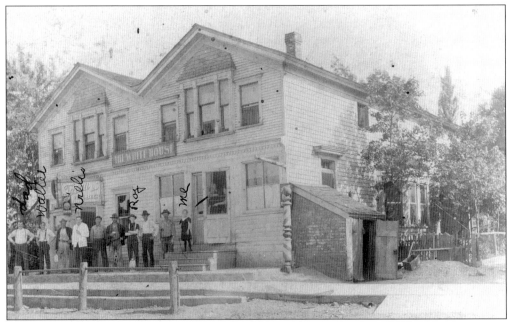

The oldest building currently standing in Lansing is the building which was once the Busak Tavern. Built in 1860, it was purchased by Christian Busak in 1875. At the time he bought the building, it was known as "The Half-Way House" and was a place where travelers would stay while traveling from Chicago into Indiana. Mr. Busak renamed it "The White House" and continued to run a hotel at the site. His son, William, later used the building as a general store, tavern, and dance hall. It became the location where all the town's social events took place. This photo shows the building in the late 1800s, with William Busak on the far left. (Photograph courtesy of the Lansing Historical Society.)

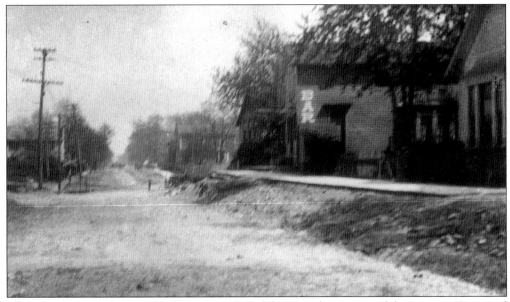

This is a side view of the Busak Tavern in 1918. (Photograph courtesy of the Lansing Historical Society.)

96

This photo shows the west side of the building in the 1950s. (Photograph courtesy of the Lansing Historical Society.)

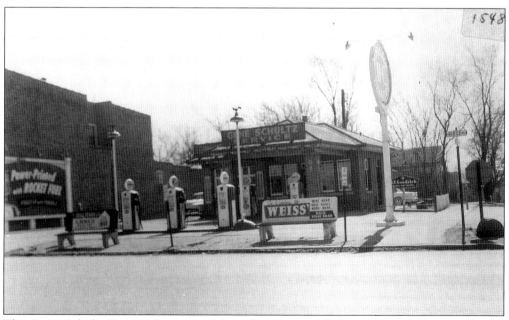

The Gene Schultz Service Station stood at the corner of Ridge Road and Sherman Street. (Photograph courtesy of the Lansing Historical Society.)

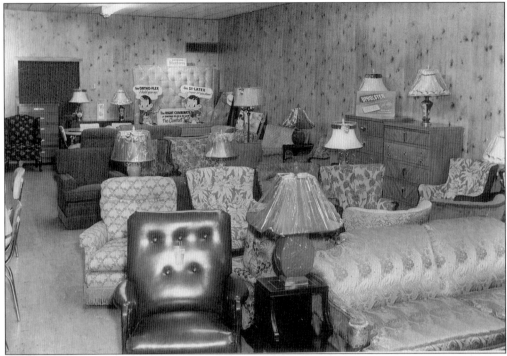

This photo shows the interior of the Evert Schultz Furniture Store, which was located at 3515 Ridge Road. (Photograph courtesy of the Lansing Historical Society.)

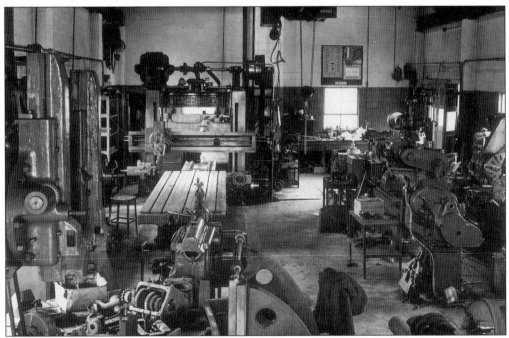

The Eenigenberg machine shop was situated behind the family home, a Sears Catalog kit house built around 1911, at the southwest corner of Glenwood-Lansing Road and Burnham Avenue, directly across from the airport. (Photograph courtesy of the Lansing Historical Society.)

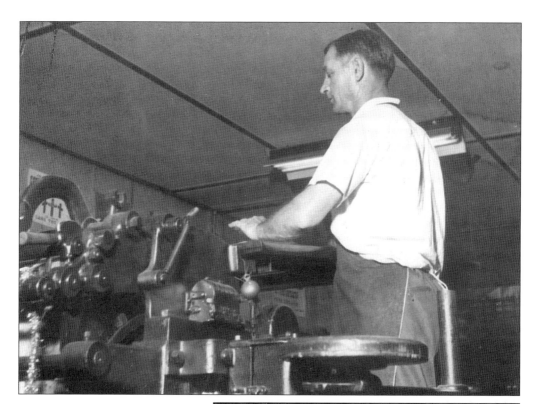

Newspaper production is quite
different today than it was in the
days of this hand-fed press,
operated by Bill Racz, on which
the *Lansing Journal* was printed.
(Photograph courtesy of the
Lansing Historical Society.)

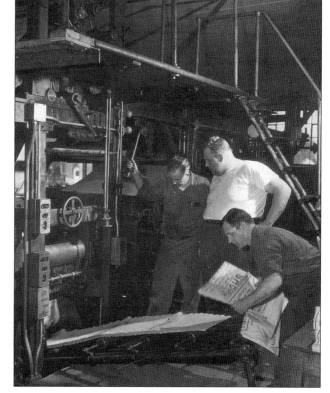

This is another shot of
newspaper production of the
Lansing Journal, the source of
local news for most of the
twentieth century. (Photograph
courtesy of the Lansing
Historical Society.)

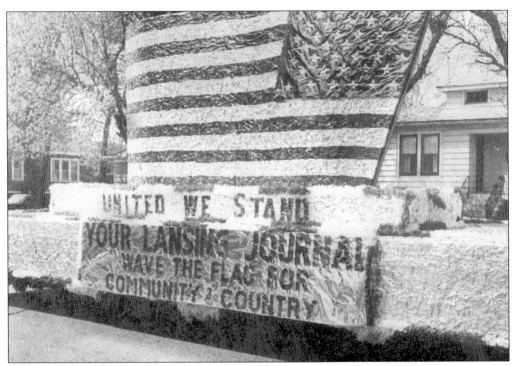

The *Lansing Journal* prepared this float for the 1954 Centennial Parade. (Photograph courtesy of the Lansing Historical Society.)

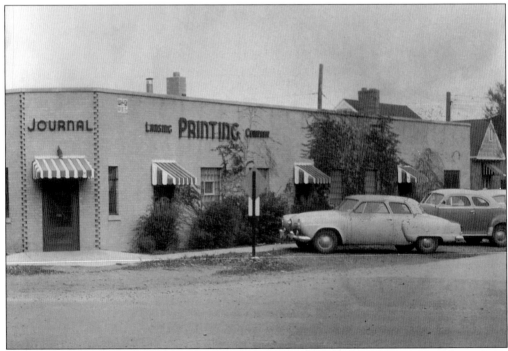

This structure at the northeast corner of Lake and William was built in 1949, and housed the offices of the *Lansing Journal* newspaper. (Photograph courtesy of the Lansing Historical Society.)

Claude Bloom operates a paper cutter at the *Lansing Journal* offices. (Photograph courtesy of the Lansing Historical Society.)

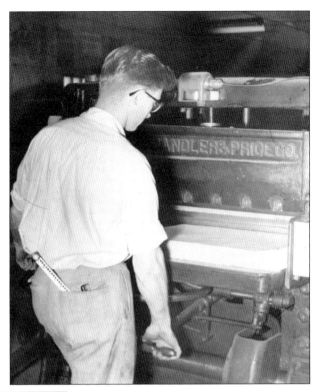

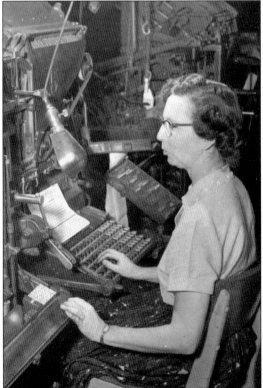

Long before the use of computers, Gertrude Anderson used a Lineotype machine to prepare newspaper copy. (Photograph courtesy of the Lansing Historical Society.)

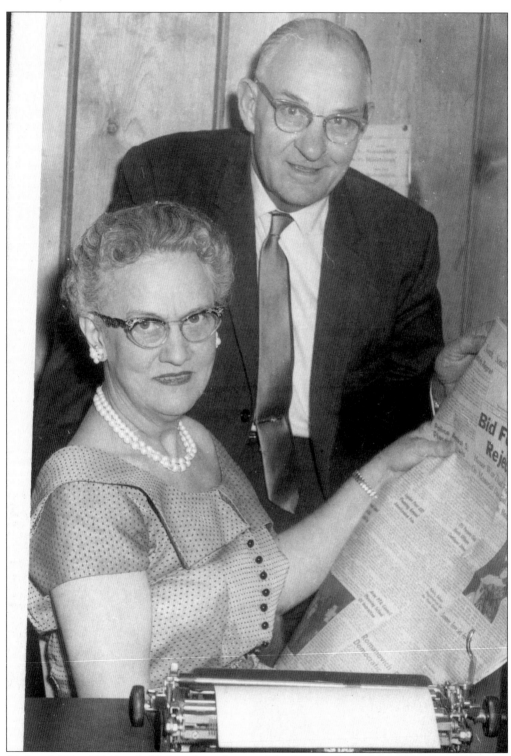

Carl and Olive Wulfing hold their last edition of the *Lansing Journal* in 1960, after selling the business. (Photograph courtesy of the Lansing Historical Society.)

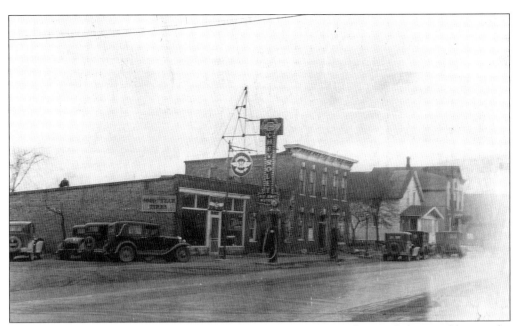

Ridgeway Chevrolet is the oldest car dealership in Lansing and one of the 10 oldest in the country, started in 1927. Four generations later, they are still in business a few blocks north of this location on Torrence Avenue. This photograph is c. 1946. (Photograph courtesy of the Lansing Historical Society.)

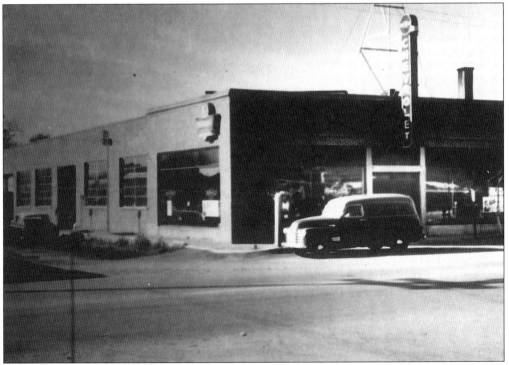

Ridgeway Motors is shown here as it appeared in the 1940s, just a fraction of the size of the current building. (Photograph courtesy of the Lansing Historical Society.)

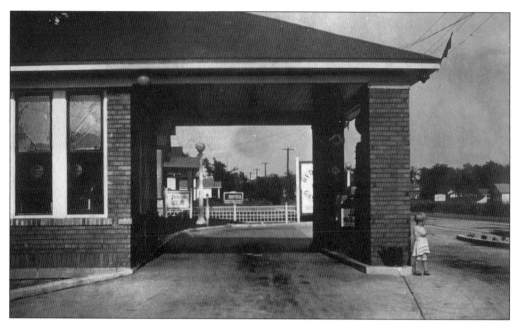

This 1925 gas station was located at the corner of Ridge Road and Torrence Avenue. (Photograph courtesy of the Lansing Historical Society.)

This photo is believed to be of John Swart, who at one time owned a general store in Lansing. (Photograph courtesy of the Lansing Historical Society.)

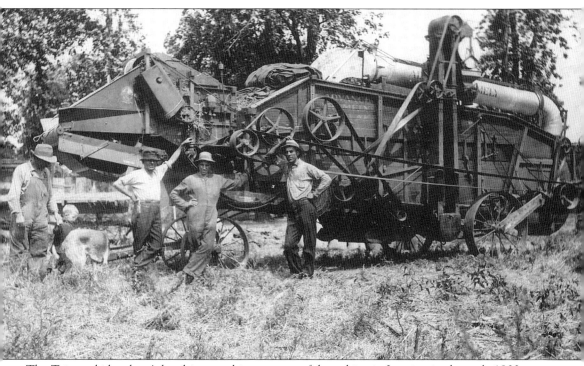

The Trinowski brothers' threshing machine was a useful machine in Lansing in the early 1900s. (Photograph courtesy of the Lansing Historical Society.)

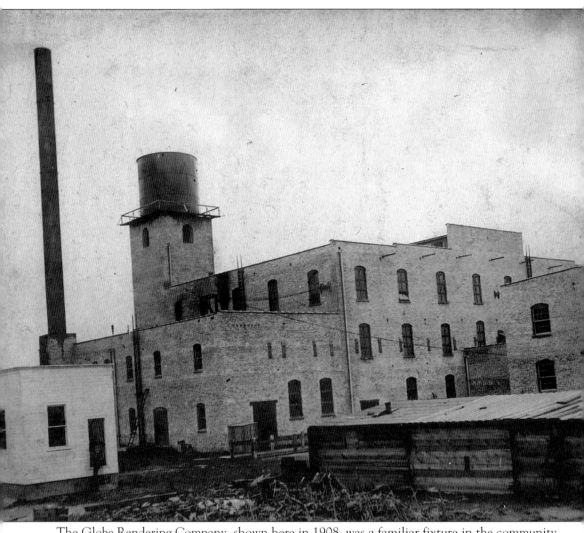

The Globe Rendering Company, shown here in 1908, was a familiar fixture in the community of Bernice, located north and west of Bernice Road. (Photograph courtesy of the Lansing Historical Society.)

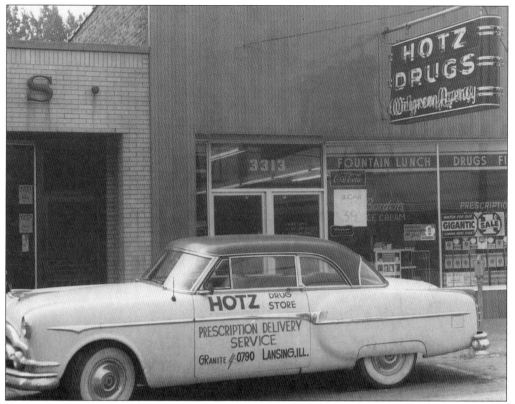

The Hotz Drug store offered more than just pharmaceutical products. Grocery items could be purchased, and you could also get a fountain soda. The drug store remained on Ridge Road until the early 1990s. Notice that behind the delivery car is a parking meter, which is also absent on today's Ridge Road. (Photograph courtesy of the Lansing Historical Society.)

The Burnham Pharmacy, pictured here, was another drug store to service the Lansing area. (Photograph courtesy of the Lansing Historical Society.)

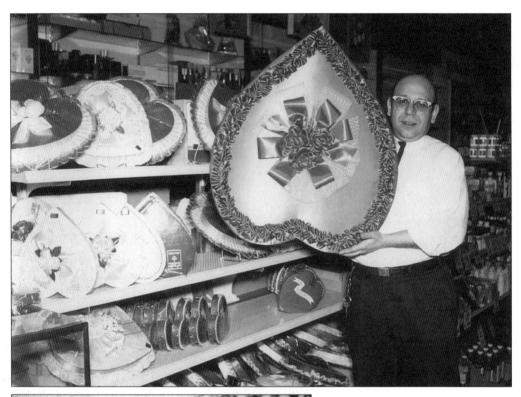

Valentine's Day was obviously a time of big sales at the Lansing Pharmacy. Chris Kovacheff displays an enormous heart filled with sweets that made one Lansing lady very happy. (Photograph courtesy of the Lansing Historical Society.)

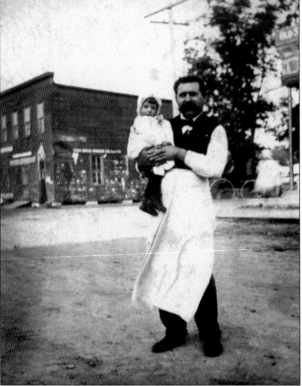

Mr. Nufer stands in front of his saloon with his child. The large building on the left was Henry Bock's Hardware Store. (Photograph courtesy of the Lansing Historical Society.)

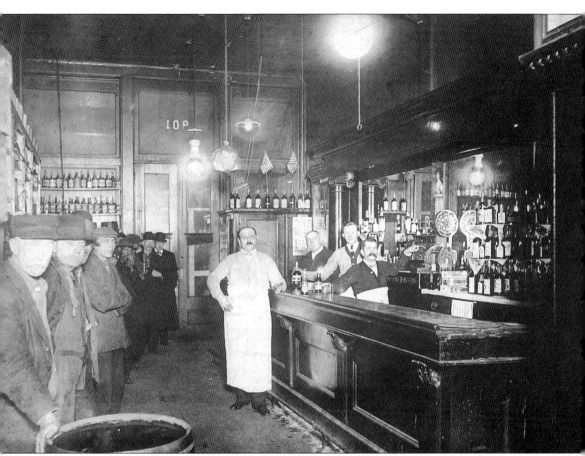

Nufer's Tavern on Torrence Avenue was a popular gathering spot for the men of Oak Glen. (Photograph courtesy of the Lansing Historical Society.)

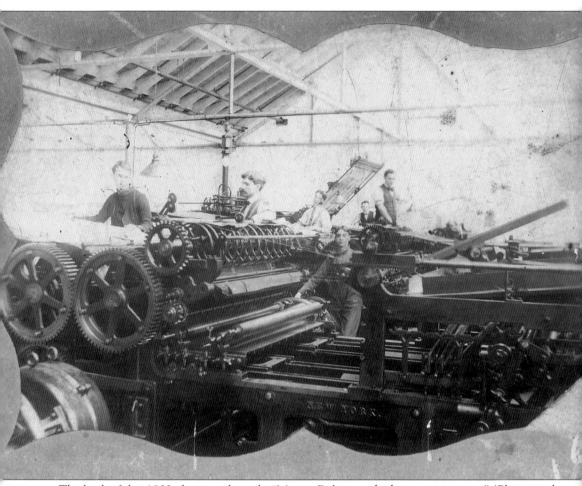

The back of this 1903 photograph reads, "Martin Bultga worked at printing press." (Photograph courtesy of the Lansing Historical Society.)

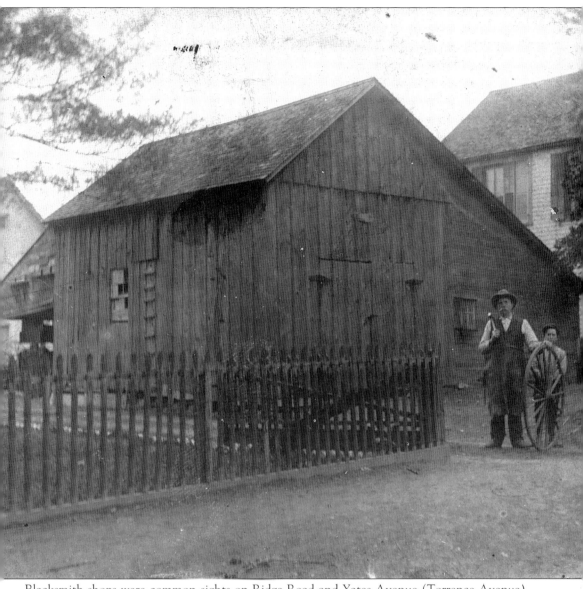

Blacksmith shops were common sights on Ridge Road and Yates Avenue (Torrence Avenue) in the late 1800s. (Photograph courtesy of the Lansing Historical Society.)

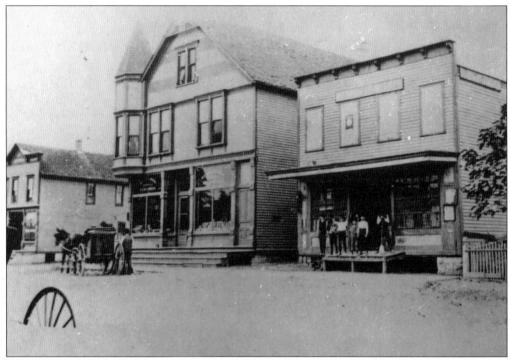

The William Winterhoff Grocery Store on Ridge Road is pictured here in 1901. The building on the right was originally Henry Lansing's store and Lansing's first post office. (Photograph courtesy of the Lansing Historical Society.)

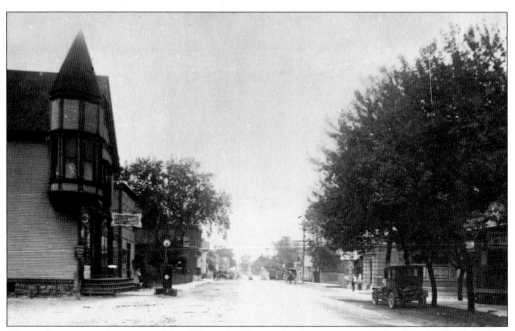

Shown here is another view of the Winterhoff store, looking west on Ridge Road. This building stood where Gus Bock Ace Hardware is now located. (Photograph courtesy of the Lansing Historical Society.)

Before the current site of the Fashionette was built, this century-old building on Ridge Road, which housed a doctor's office, was torn down to make way for the new store. (Photograph courtesy of Jackie Protsman.)

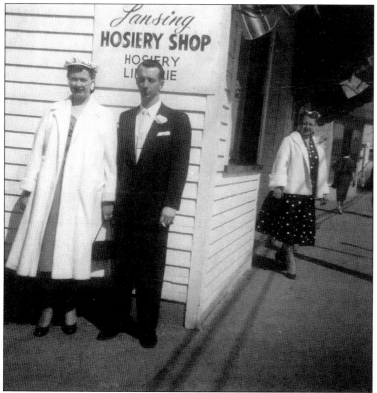

Florence Aumick and her husband, John, stand outside their business, the Lansing Hosiery Shop, in 1955. The business, which began in 1953, later became known as the Fashionette, specializing in women's clothing and is still in operation today by daughter Jackie Protsman. (Photograph courtesy of Jackie Protsman.)

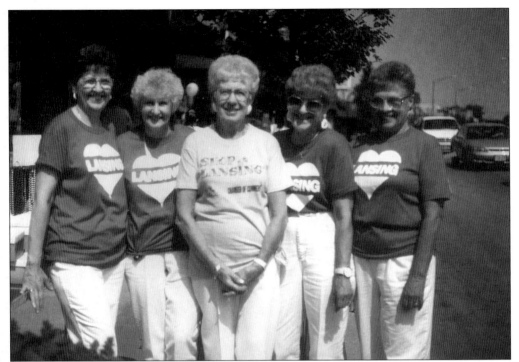

In 1993, Lansing celebrated the centennial of its incorporation. Pictured here during one of the centennial activities are the women of Lansing's Fashionette. They are, from left to right: Joan Pitchford, Marie Darragh, owner Jackie Protsman, Clara Fallon, and Lois Novak. (Photograph courtesy of Jackie Protsman.)

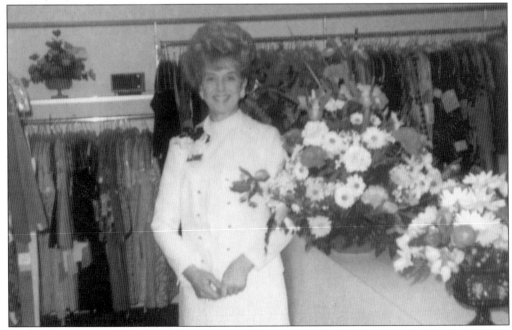

Jackie Protsman stands beside the counter of her store, the Fashionette, in March of 1973. (Photograph courtesy of Jackie Protsman.)

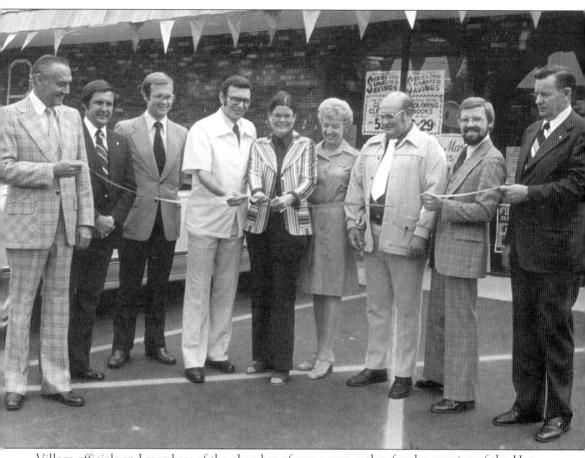

Village officials and members of the chamber of commerce gather for the opening of the Hotz II Drug Store on Ridge Road. (Photograph courtesy of Jackie Protsman.)

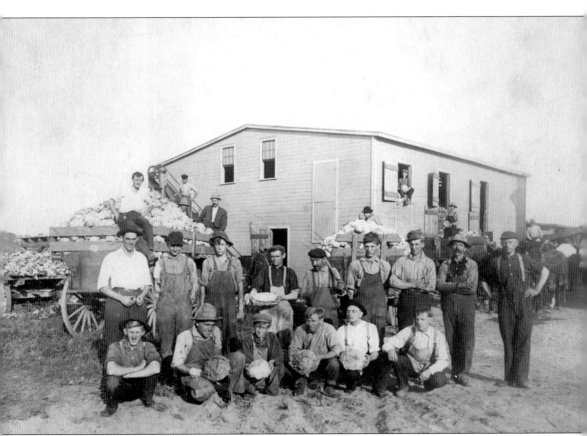

Pictured are the employees of the Meeter Sauerkraut factory, which was located at Wentworth Avenue at the Pennsylvania Railroad tracks. Farmer John Meeter had a large abundance of cabbage one year, which he shredded into sauerkraut, and his business grew from there. (Photograph courtesy of the Lansing Historical Society.)

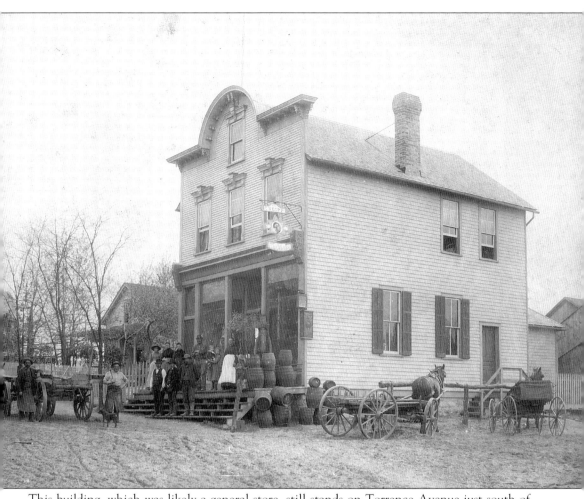

This building, which was likely a general store, still stands on Torrence Avenue just south of Thornton-Lansing Road. It is now Middleton's Furniture Store. (Photograph courtesy of the Lansing Historical Society.)

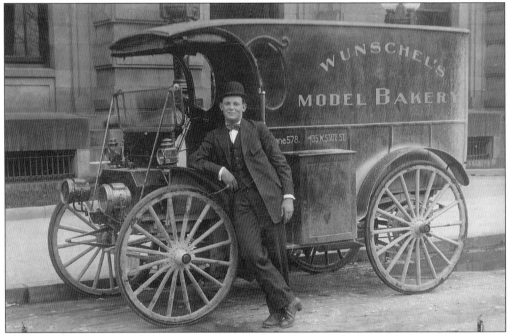

The Wunschell's Bakery delivery truck is shown here in the early 1900s. (Photograph courtesy of the Lansing Historical Society.)

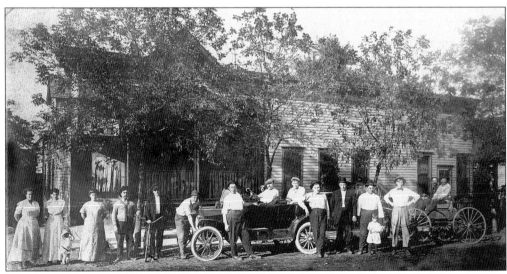

Some Lansing residents stand in front of one of Lansing's early taverns. This building stood at the location that is now Kilroy's. (Photograph courtesy of the Lansing Historical Society.)

Nine

THE RAILROAD
AND BRICKYARDS

"Our big thrill as kids was to go to the Oak Glen train station and watch as the mail would come in and get picked up. The train never stopped. The postmaster would hang the outgoing mail on a hook next to the track. As the train went by, he would throw the incoming mail out the door, and a hook would snare the outgoing mail."
—Don Olson, lifelong resident of Lansing, born in 1927,
and president of the Lansing Historical Society.

The Pennsylvania Railroad first serviced Lansing in 1861. The train depot still sits along the tracks just south of Ridge Road, although the tracks have been out of service for years. This photo shows the depot from the backyard of a home near the tracks. (Photograph courtesy of the Lansing Historical Society.)

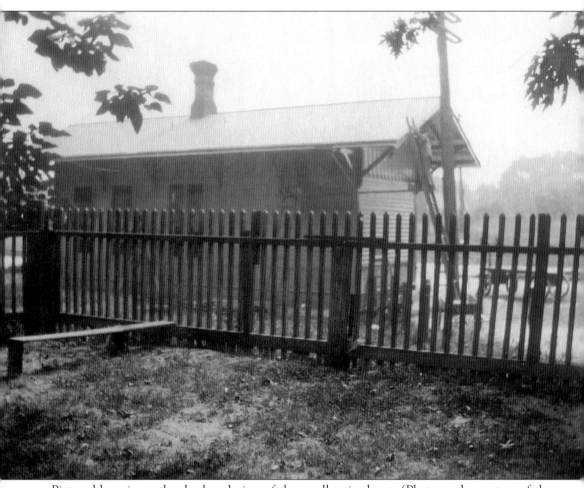

Pictured here is another backyard view of the small train depot. (Photograph courtesy of the Lansing Historical Society.)

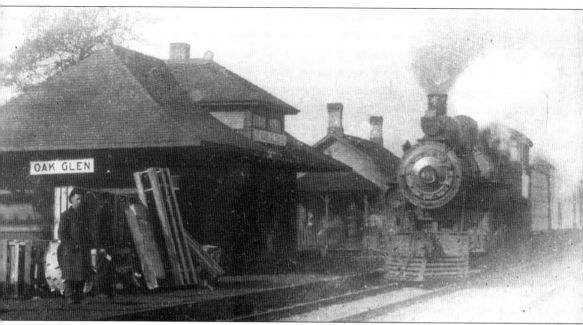

The Grand Trunk Train Depot in Oak Glen is shown here around 1900. (Photograph courtesy of the Lansing Historical Society.)

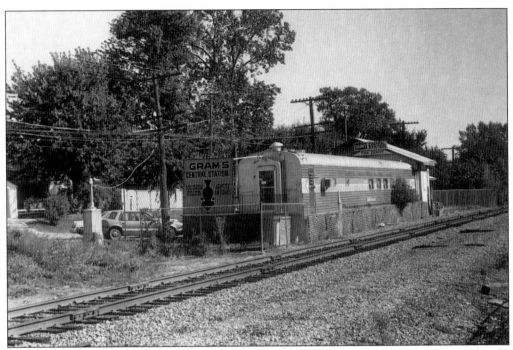

After the Pennsylvania Railroad discontinued use of these tracks, the train depot briefly became "Gram's Central Station," a gift shop and ice cream parlor. (Photograph courtesy of the Lansing Historical Society.)

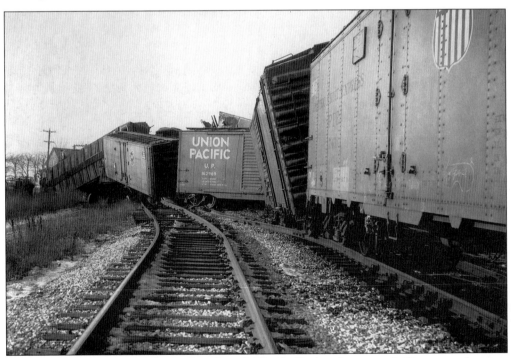

This train wreck occurred on the Grand Truck Railroad, west of Torrence Avenue. (Photograph courtesy of the Lansing Historical Society.)

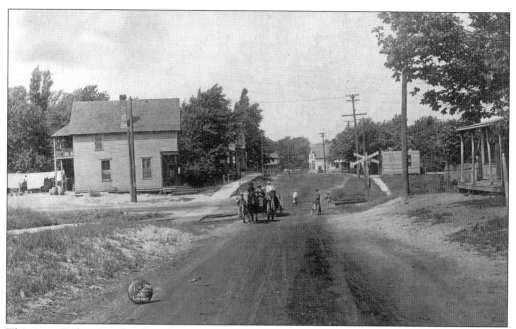

This is a Ridge Road railroad crossing around 1900. (Photograph courtesy of the Lansing Historical Society.)

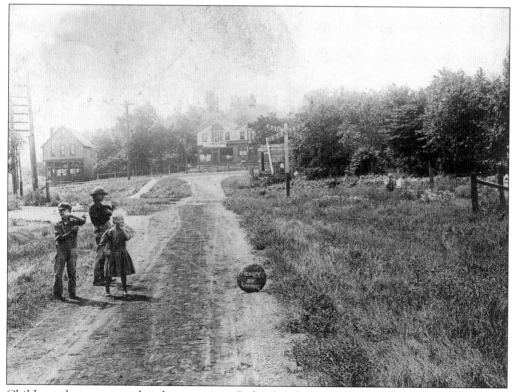

Children play near a railroad crossing on Ridge Road. (Photograph courtesy of the Lansing Historical Society.)

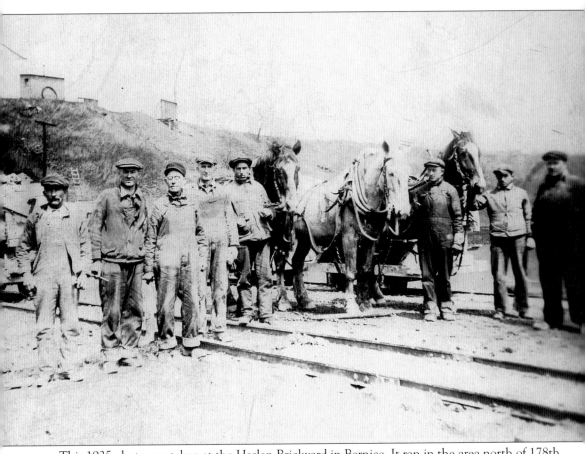

This 1925 photo was taken at the Harlan Brickyard in Bernice. It ran in the area north of 178th Street between Chicago Avenue and Torrence Avenue. Four of the five brickyards in the area were located in Bernice. Individuals in the photo are Kasper Bessinger, Joe Lessner, Max Trinowski, Louis Herman, Richard Schultz, August Schultz, Delphus Latulipe, and George Pearson. (Photograph courtesy of the Lansing Historical Society.)

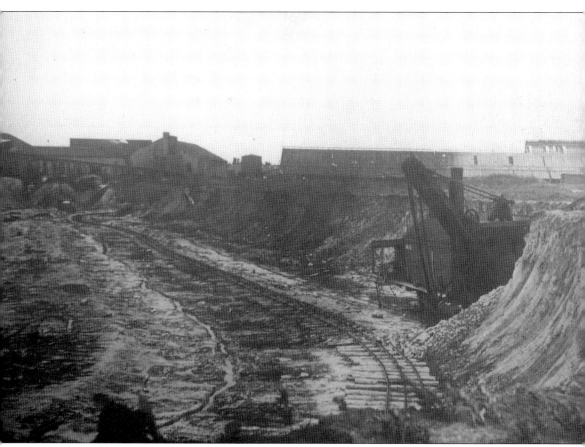

This photo shows a steam shovel and track running through a Lansing brickyard. (Photograph courtesy of the Lansing Historical Society.)

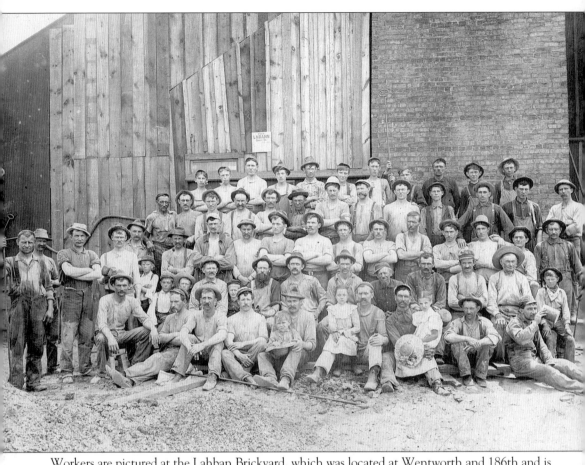

Workers are pictured at the Lahban Brickyard, which was located at Wentworth and 186th and is now the site of the Lansing Country Club. (Photograph courtesy of the Lansing Historical Society.)

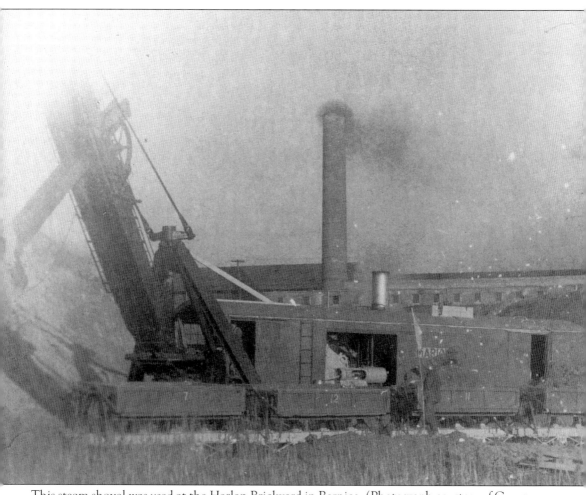

This steam shovel was used at the Harlan Brickyard in Bernice. (Photograph courtesy of George Dommer.)

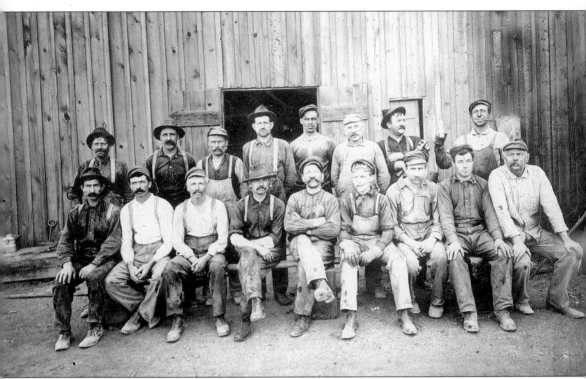

Pictured in front of the boiler room are some of the workers of Illinois Brickyard 30 in 1925. This brickyard opened in 1887, and others followed in the 1890s. In the late 1800s, the brickyards and the railroad employed most men in the area who were not farmers. Reportedly, much of the brick used to rebuild Chicago after the great fire came from Lansing. By the early 1970s, the last of the brickyards had become a landfill. Some of Lansing's other brickyards have become small lakes, including those at the Lansing Country Club and Knights of Columbus grounds. (Photograph courtesy of the Lansing Historical Society.)